RÉPUBLIQUE FRANÇAISE

CARTE POSTALE

Ce côté est exclusivement réservé à l'adresse

*French
Postcards*

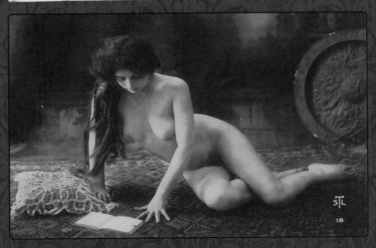

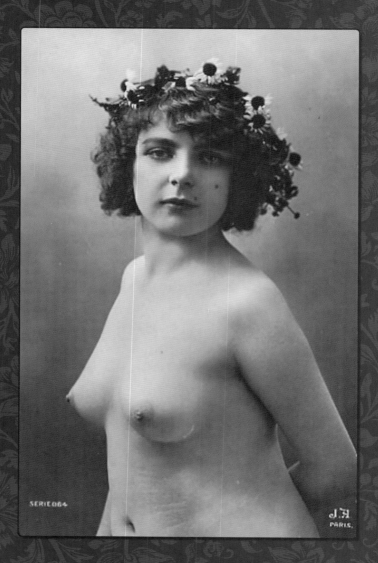

SERIE 064

J.A.
PARIS.

French Postcards

An Album of
Vintage Erotica

MARTIN STEVENS

Universe

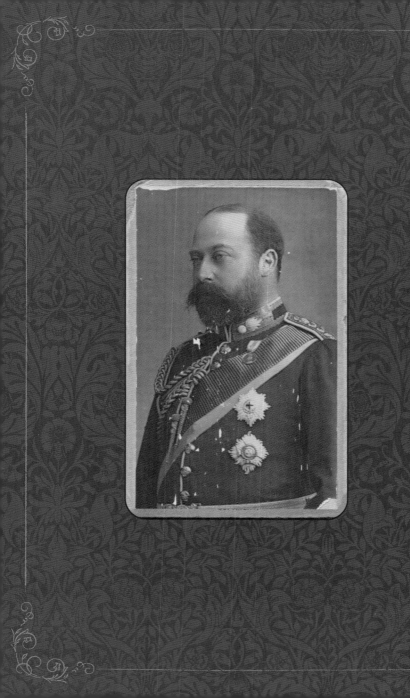

For the man who
inspired it all, His
Royal Highness,
King Edward VII

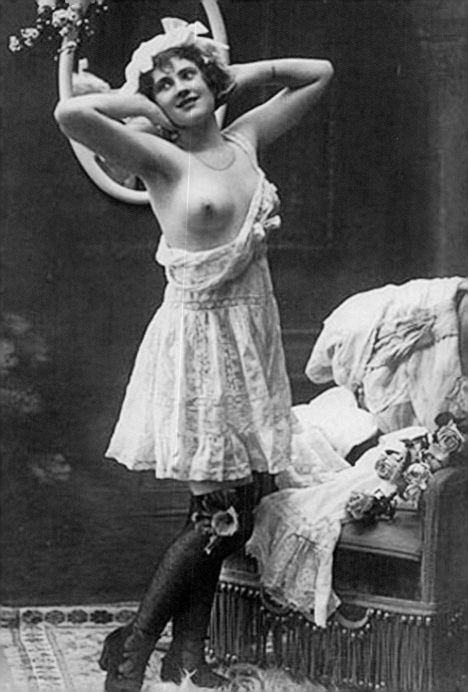

Foreword

he erotic postcard illustrates a basic tenet of the Victorian
and Edwardian eras: "Men have dreams; women fulfill
them." Left to her own devices, would a woman tolerate
torrents of lace, cascades of hair, and pointy shoes with
high heels? Would she put up with endless little buckles and straps
on her under- and outer-garments? Would she paint her face in all
hues of the rainbow? To get dolled up, it takes a lot of time nowa-
days and took even longer back then. In our modern era a woman
can say, "I'm not going to bother," and chances are good she'll
nevertheless be able to earn a living, pay her rent, and even raise
a family. But in the Victorian and Edwardian periods, very few
possibilities for achieving financial independence were available to
women. Marriage was almost the only way to survive. Women had
the job of trying to choose for a husband the least bad man with the
best possible finances.

An eligible girl knew just what a potential husband wanted in a
wife. Desired especially were innocent maidens who looked frail and
helpless—delicate beauties with tiny feet under vast skirts, piles of
hair, and enormous hats. As upholstered as their furniture, Victorian
women were living examples of their husbands' ability to take care
of them. The fantasy of a secret lover, an exotic mistress hidden in
a boudoir across town, existed as a world apart from respectable
married life.

Some enterprising women of the day saw in this their unique opportunity to make their own fortunes off men's fantasies. They took advantage of their situation as status symbols by inciting their admirers to compete for their affections. By offering themselves as the ultimate prize to be won, they became rich off the spoils of the combat. These women were known as *Les Grandes Horizontales*. There was Cléo de Mérode, mistress to the king of Belgium, and La Belle Otero, a Spanish adventuress with a remarkable jewel collection. Cora Pearl was an English temptress famous for her twin abilities to ride well and get money away from wealthy men. Perhaps the queen of the bunch was Liane de Pougy, known for her ladylike beauty, fabulous wardrobe, and impressive jewelry. And before them all had come Marguerite Gauthier, the inspiration for Giuseppe Verdi's masterpiece opera, *La Traviata.*

Les horizontals was originally a reference to the transverse lines of space and horizon felt necessary for a great painting. It evolved to mean those great beauties who made themselves horizontal for a great price. It was said that Liane de Pougy's price was 1,500 francs, a vast amount of money then. As the story goes, one year all the cadets of the military academy of Saint-Cyr held a drawing. Each cadet, of the 1,500 in all, had contributed one franc. The winning cadet took the collected sum to the bedside of Liane de Pougy. The morning after his night of pleasure, he told her how he happened to be there. She was so impressed that she swept to her dressing table and said, "It is such an honor that the cadets of Saint-Cyr have given me that I want to return your money, so that you can always say that you slept with Liane de Pougy for nothing!" And she gave him back his one franc.

This story, true or not, embodies the mystique that sexual decadence held in the era. This world of forbidden women attained mythological status around the turn of the twentieth century. Painters and sculptors evoked it in their work—William-Adolphe

Bouguereau's nymphs, Gustav Klimt's lovers, and Henri de Toulouse-Lautrec's dancers. A new vocabulary of sexual fantasy was created, which, not unlike the geisha culture of Japan, developed its own rituals, symbols, and celebrities. With the advent of photography as a means of mass communication, this new eroticism found expression in the postcard. For the man on the street, the soldier far from his girl-next-door, and foreign tourists visiting Paris in particular, the postcard of a beauty in her boudoir was the inexpensive and immediate mode of transport to this world.

In the repressed and feverish imaginations of Victorian men, these pictures carried an unbelievably strong erotic charge. As is so often the case, their semi-draped nudity, half-revealed stocking tops, and daring glimpses of décolletage indicated pleasures more tantalizingly than less artful images would. (The word *décolletage* literally means something coming unglued, unstuck, falling open.) The postcards spelled temptation, and the photographers and postcard manufacturers of the period understood this. The businessmen behind the postcard industry were certainly that: men. It is highly unlikely any women were behind the scenes. They were the subjects of these postcards and the photographers were expert in revealing just so much and no more.

French postcards offer peeks into a realm many of the purchasers would never know: the realm of the *maison clos*, where any and all erotic delights could be had for a price. One of the most famous in Paris had exotic rooms with themed décor—Oriental, Arabic, futuristic. Wealthy gentlemen could explore the pleasures of this realm if they had the money. For the rest, there were the pictures.

The Prince of Wales, the portly son of Queen Victoria who would later become King Edward VII, was one famously randy patron of the *maisons clos*. In one of these houses he even had a special chair designed to make sexual sporting easier on the royal person and not too difficult for his partner. There is a famous story

told by one of the prince's friends about a yachting trip on the Mediterranean with some ladies who were no better than they should be. Passing the prince's cabin the friend heard him ask of his young partner, "Will you please stop calling me Your Highness!"

The cards suggesting interludes of illicit romance were sold everywhere about Paris and other large European cities but were always known as *French* postcards. Newspaper vendors had them stocked under the counter. They were on the Champs-Élysées, in the gardens of the Tuileries, under the Eiffel Tower, everywhere both tourists and natives would be. As the years progressed and the First World War came the cards became more overt. More flesh was exposed. The camera work became less gauzy. The women pictured became less the inaccessible goddess and more the flirty flapper you might very well run into on the street.

After World War I, new modes of communication edged the postcard out of fashion. Magazines and motion pictures overtook naughty postcards as technology brought new media to new audiences. Erotic fantasies evolved, too, as society relaxed its strictures. The once-scandalous images on French postcards lost their edge, becoming more and more quaint and romantic as inhibitions fell away with the decades. But even today their descendants can be found at beach resort souvenir shops and in racks at newsstand kiosks. These new incarnations of the French postcard are even milder than in the days when men with moustaches sold them surreptitiously on the *grands boulevards.*

Martin Stevens's fetching and fun book takes us back to this lost, more innocent time—an era that was in many ways much sexier because so much was forbidden. Sex requires taboos to test our boundaries and pique our curiosity. We can only guess in today's anything-goes modern world how much more exciting sex used to be. These postcards give us a clue.

—DAVID LEDDICK

Introduction

The images in this book might seem fairly innocuous given what is shown nowadays on television, in the movies, and on the Internet. But upon closer inspection, you will discover a certain titillation here not to be found anywhere else in today's media. I distinctly recall the experience years ago when I first unexpectedly stumbled upon a treasure trove of French postcards. They were hidden in a moldering shoe box in my great-grandfather's attic. While the nudes themselves weren't especially naughty, there was still about them the thrill of something forbidden. My imagination spun thinking of how sensational these photos must have been for the young men of their day, including my great-grandfather and his buddies. This was a whole new, saucy world that I had uncovered with these captivating photos.

Later, when I began a career in the graphic arts, I became an avid collector of fine art photography, but the impression made by the French postcards remained. I began to search for them on my travels, but instead of browsing in fashionable galleries, I was rooting through Paris flea markets, digging around dusty London antique stalls, and visiting postcard shows and forgotten junk shops in New York. Today these photographs are recognized as a minor art form, and the rare originals have become valuable antiques and souvenirs of a sweeter time.

The history of erotic photography begins almost immediately after the birth of photography itself. No other subject has so completely and consistently dominated artistic endeavor as the human body has. The later half of the nineteenth century saw many technical innovations in the medium. Henry Fox Talbot patented the calotype, the first negative-positive process, which made reproduction much easier. This development allowed personal and portable mass-produced photographs to become more and more accessible to the middle classes.

The plain postcard, with one side reserved for the addresses and stamp and the other side blank for a message to be written, was introduced in Austria in 1869. But the notion of putting an image on one side of a postcard did not come about until later. Picture postcards got their impressive first send-off at the Paris Exhibition of 1889. There, fashionable Parisians were able to mail a card from the top of the Eiffel Tower. Meanwhile, advances in photography brought new immediacy to artistic representation: where exposure times had once been upwards of ten minutes, now they were sufficiently brief to allow comfortable posing for human subjects.

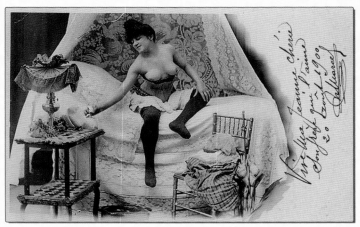

Published nude photographs were introduced ostensibly for fine art painters and sculptors, as figure or motion studies. The idea was that live models could be moody or unreliable, whereas a photograph was always available and always held still. The fashionable, portable postcard format was soon adopted for these nude images, even though initially at least none of these cards could have been sent through the post. In fact, the earliest examples had space for a written message on the same side as the image (as shown opposite). These cards were secreted away in a gentleman's pocket or hidden in the pages of a book. Thus began the golden age of the erotic postcard, which lasted from 1900 until the end of the First World War. In fact, it was American servicemen returning from Europe, smuggling their keepsakes into the country, who are mainly responsible for the arrival of French postcards in the United States. By 1910 more than 30,000 people in Paris alone were employed in the erotic postcard industry. This concentration— and France's reputation for liberality—earned all nude and erotic cards the euphemistic nickname "French postcards."

This was a time of great social and cultural change. Many of society's repressive attitudes toward sex and the human body saw new challenges at the end of the Victorian era, and an emerging middle class began to exert its strength in the marketplace. Ever on the permissive side, Paris was regarded as the world capital of licentiousness and decadence. Tourists flocked there in teeming numbers, drawn as much by the city's increasingly sexy reputation as by its historic and cultural landmarks. French postcards became a perfect souvenir. They could be bought at select street kiosks as well as mail-ordered from advertisements in men's magazines.

What was once forbidden and impossible could now be seen and held, collected and coveted. The absolute and specific reality of a particular girl—undressed, gazing at the camera—was now available for the first time to anyone. No longer was it an idealized,

conceptual body interpreted through a painter's imagination, but an actual living, naked woman. This allowed the man to feel the vicarious thrill of the voyeur, as though he were peeping through a keyhole to watch the maid or a neighbor girl undressing. The come-hither gazes, coy smiles, and naturalistic expressions on the girls' faces allowed direct and thrilling connection between the viewer and model and further distanced the erotic postcards from traditional nudes in painting and sculpture.

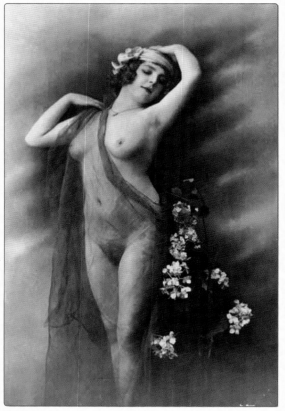

These girls embodied sexual fantasies that the everyday man would never admit to having. Themed series were popular, with progressive images playing out stages of a seduction or encounter. Women's underclothes were a bewildering series of constrictive and supportive garments, and the gradual exposure of the nude beneath figures strongly in the genre. Girls *en deshabillé* flirt bewitchingly, as though removing their clothing for the pleasure of the viewer alone. Then as now, the half-glimpsed and half-hidden are often more erotic than what is fully exposed, and the suggestion of what might follow allows the still image to exist as part of an ongoing fantasy.

Because of obscenity laws, most early erotic photography was an anonymous business, with unnamed prostitutes or second-rate dancers and actresses posing. However, virtually all photographers placed a signature mark on the cards they made (as shown above). The king of these was Jean Angelou, who put out an amazingly prolific body of work from 1900 until around 1916. During those years, many young girls were immortalized in his top-floor *atelier* in Paris. (His favorite model, Miss Fernande, is shown opposite in an unmarked photograph by Jean Angelou.) His glass-roofed studio was enormous and housed enough props, costumes, and set pieces to equip a small theater company. Interestingly, most photographs of the time were done with natural lighting, as the genre was too young for supporting technology—such as studio lights—to have been invented yet. Angelou's death in 1921, along with the advent of new forms of image communication after World War I, signaled the end of an era. Less innocent days were ahead.

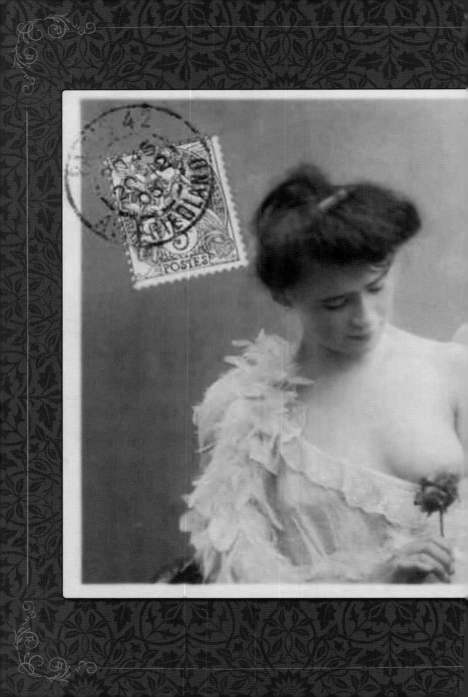

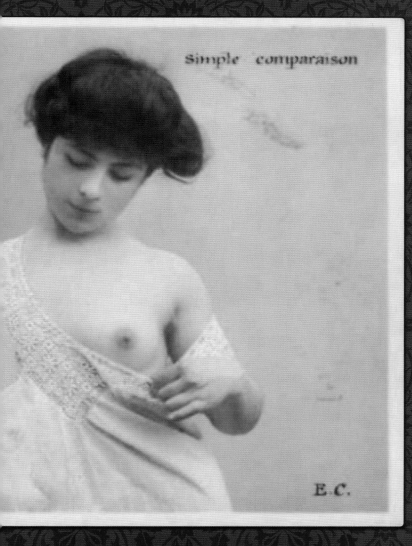

Simple comparaison

E.C.

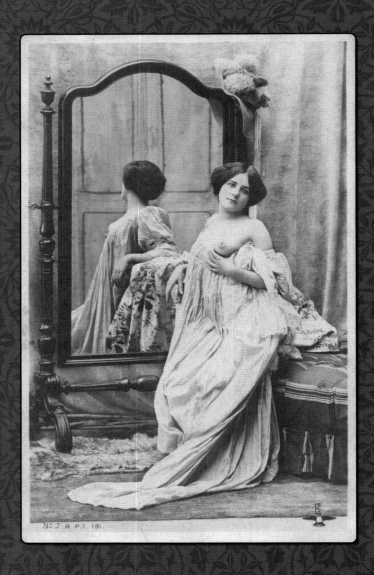

Nº 2. A. P. 1. 191.

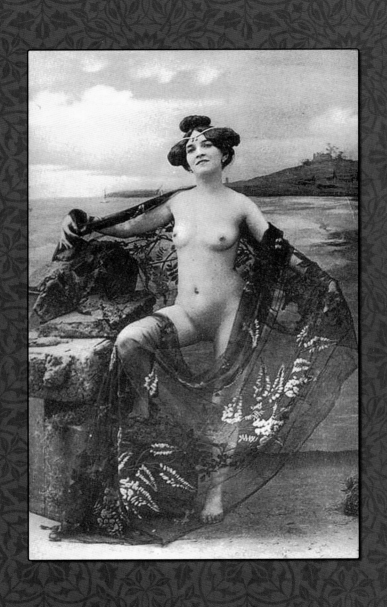

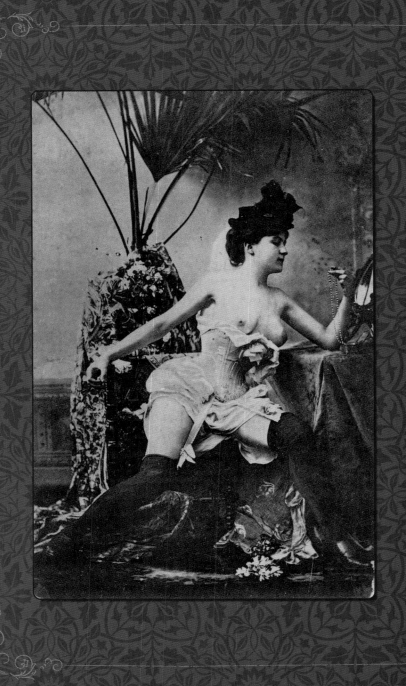

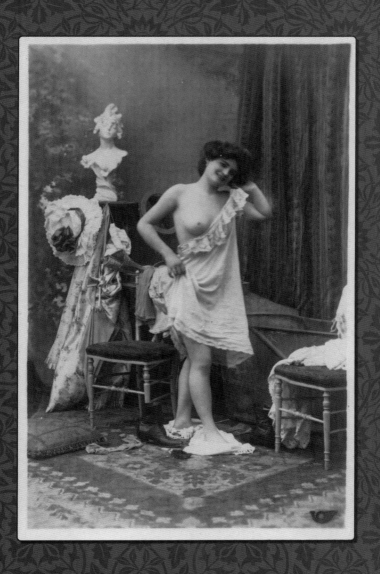

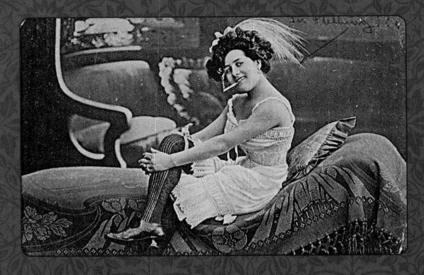

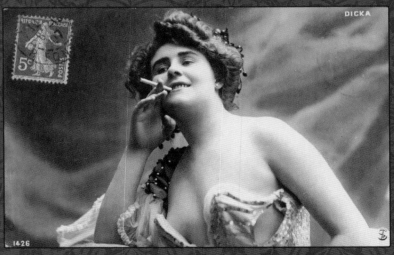

DICKA

1426

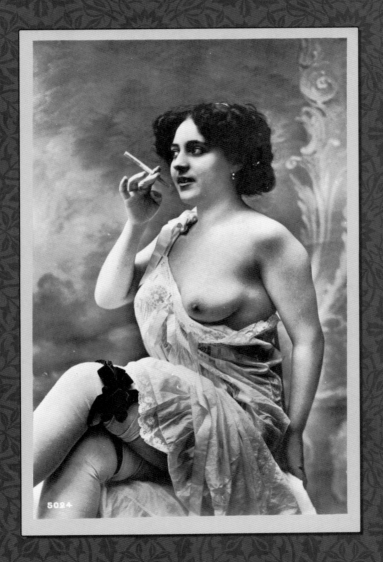

5024

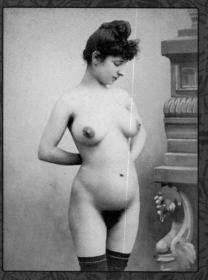
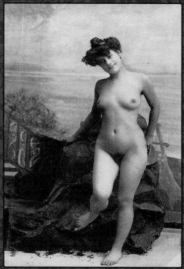
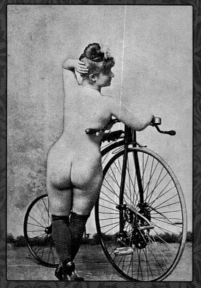
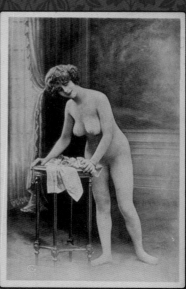

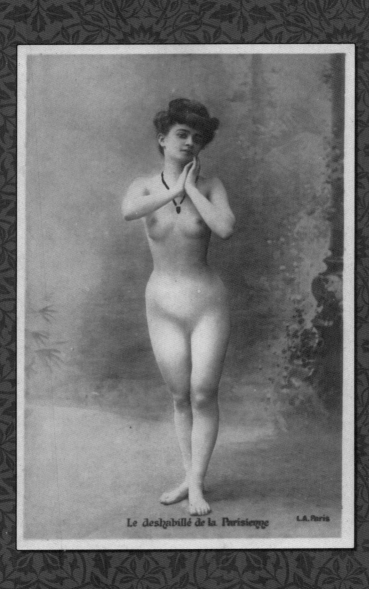

Le deshabillé de la Parisienne L.A. Paris

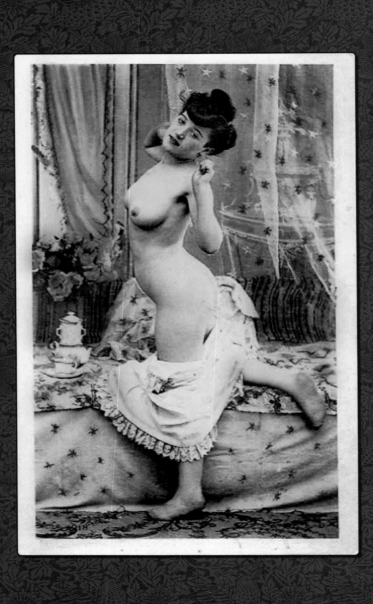

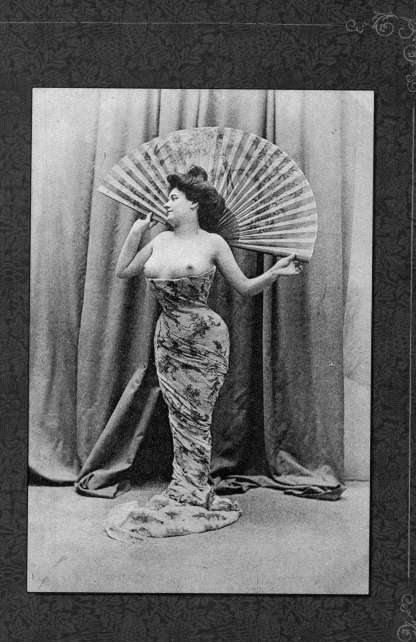

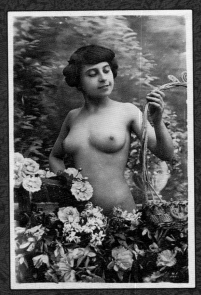
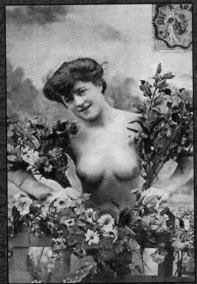
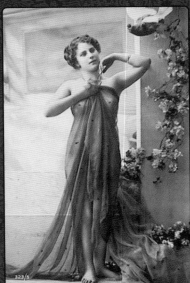
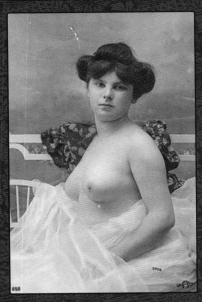

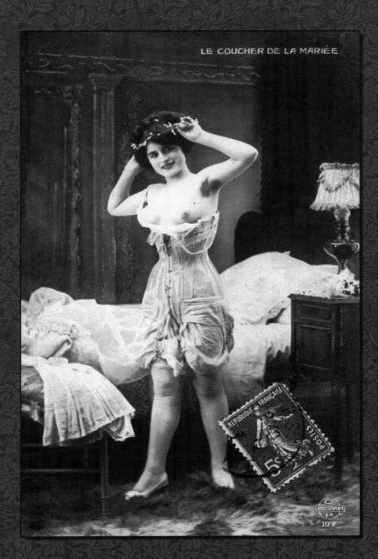

LE COUCHER DE LA MARIÉE

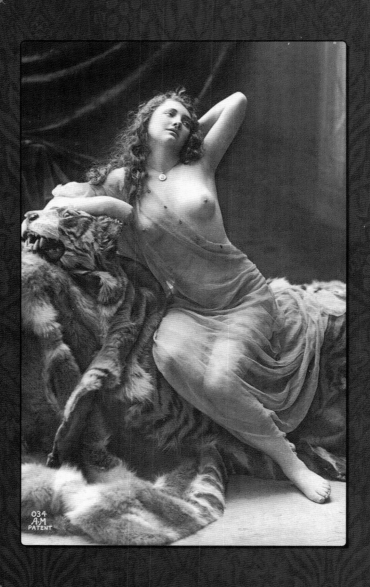

034
A·M
PATENT

Louis-Amédée Mante

Among the many photographers creating these
postcards, one stands out. Louis-Amédée
Mante had loftier aspirations for the nude.
His wish was to create art, beautiful and
romantic museum-quality nudes resembling
classic paintings. He also invented a new way to
engrave photographs on steel and would thus
sign his photographs "AM PATENT." Mante's
work is theatrical and grand, replete with
costumes, props, and lavish settings. His life
was similarly dramatic: he played the bass in an
opera orchestra, and his three daughters—all
prima ballerinas, collectively known as Mante's
Beautiful Ones—posed for Edgar Degas's
ballet paintings. It was rumored that one of his
daughters modeled for him.

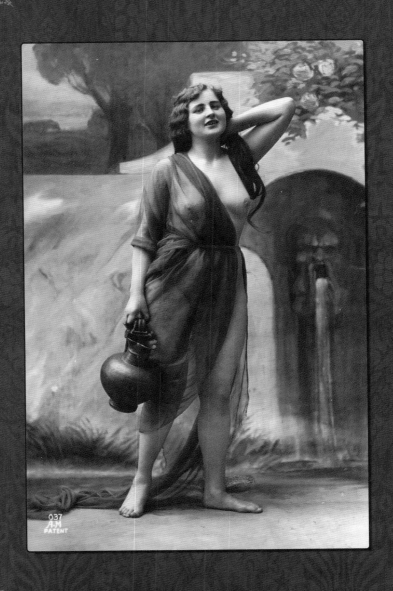

037
A.M
PATENT

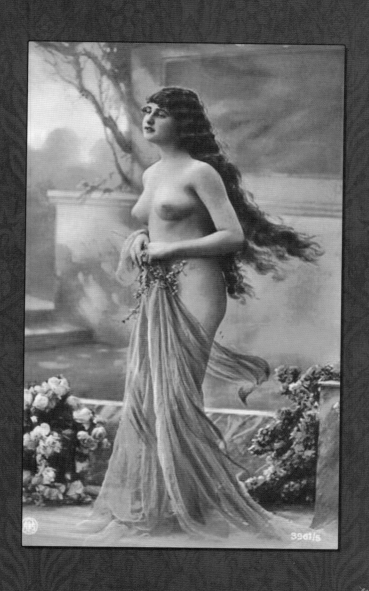

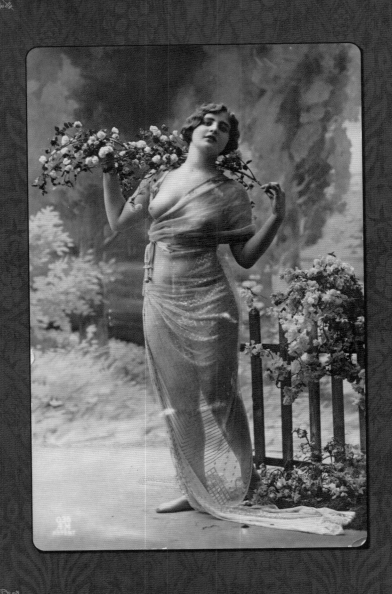

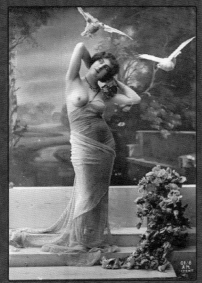
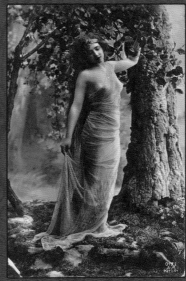
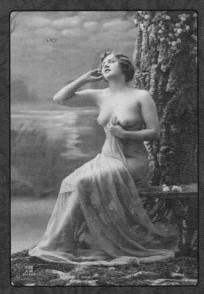
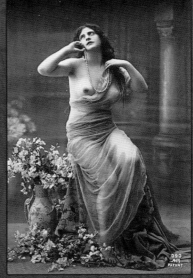

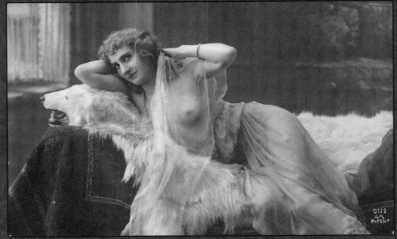

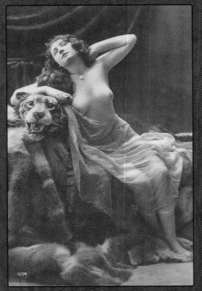

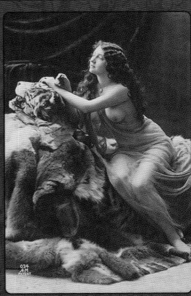

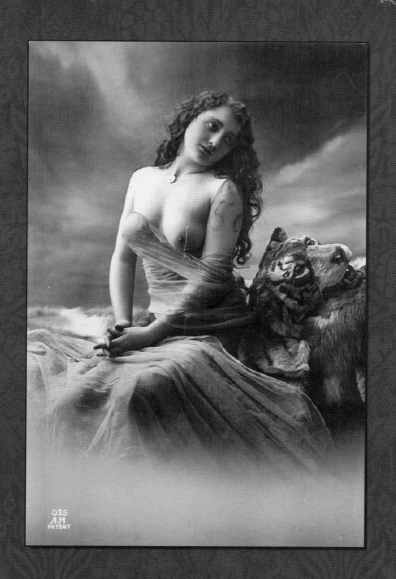

035
A.M
PATENT

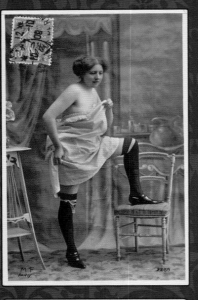
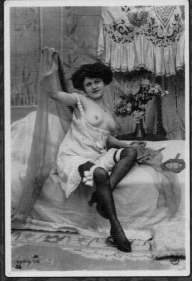
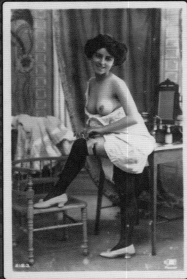
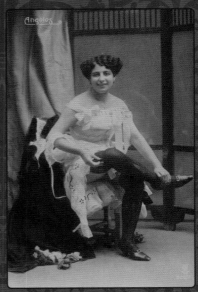

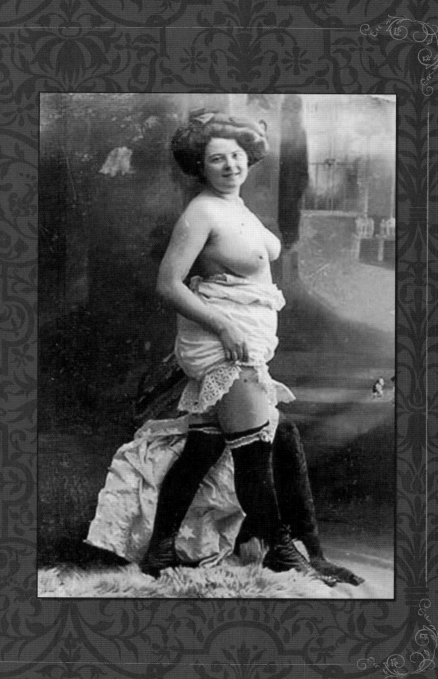

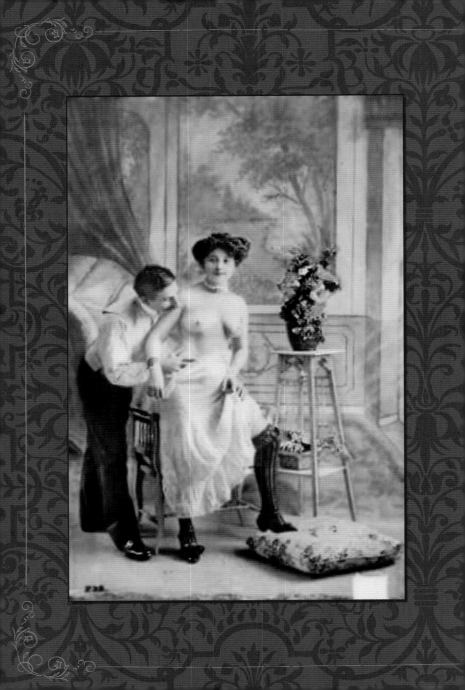

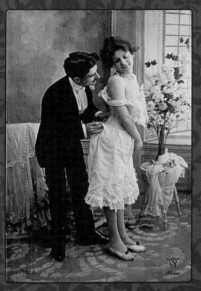

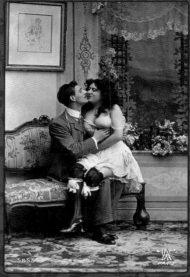

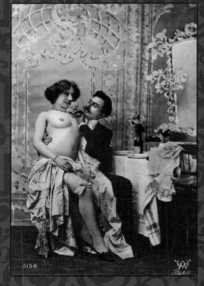

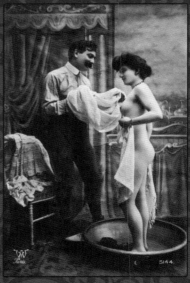

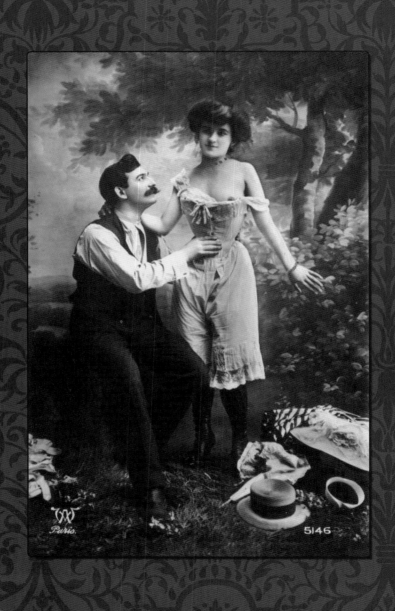

Paris.

5146

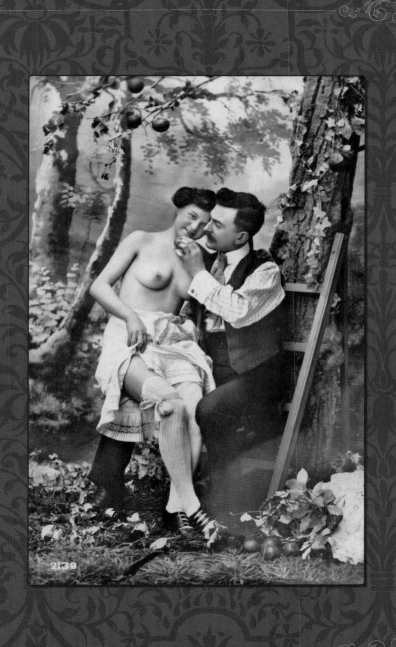

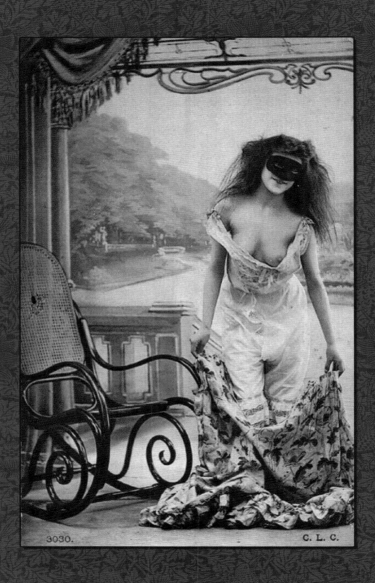

3030.

C. L. C.

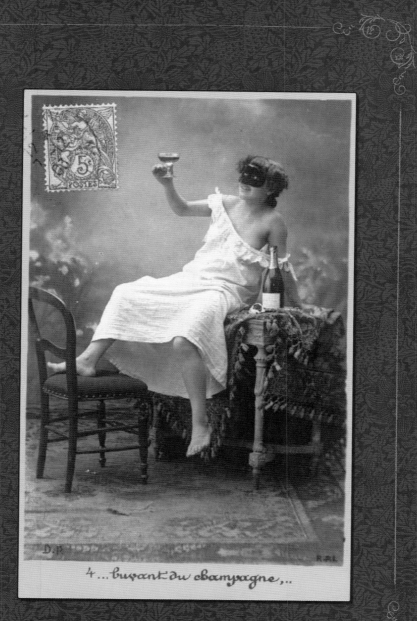

4 ... buvant du champagne ...

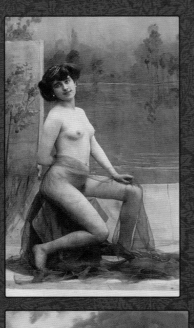
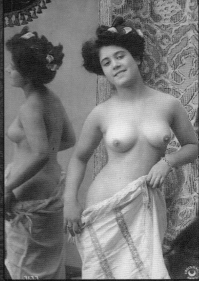
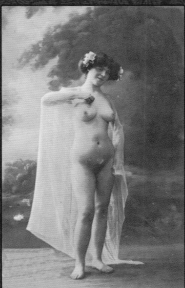
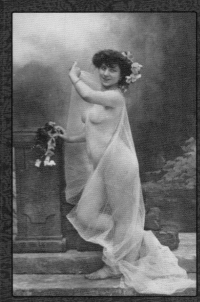

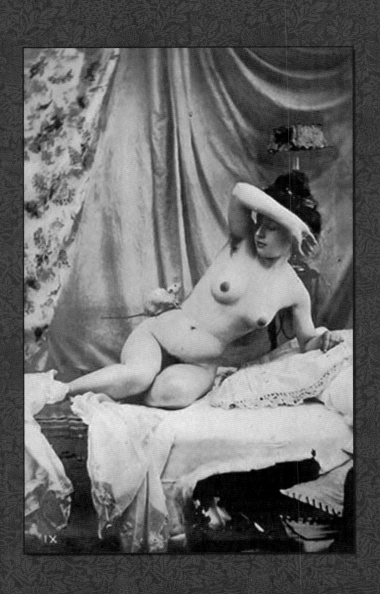

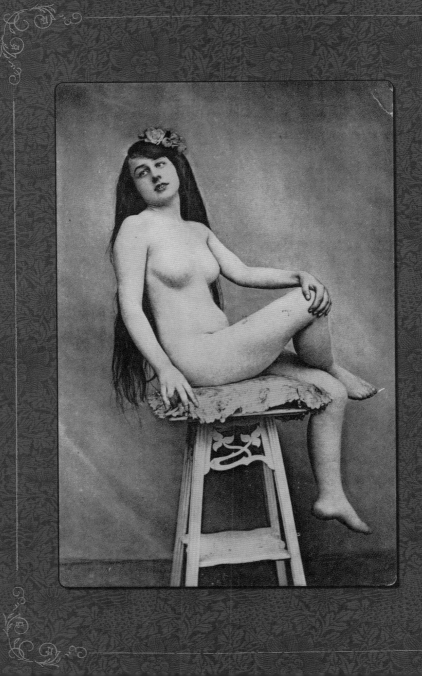

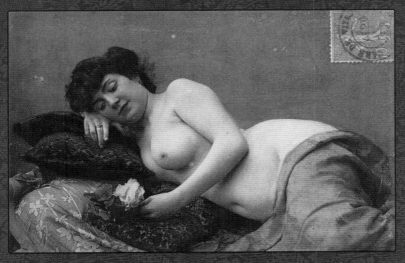

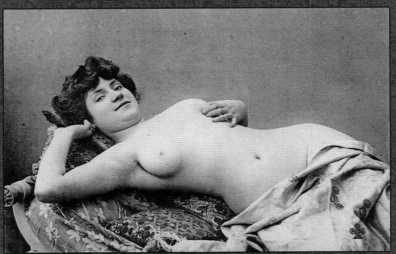

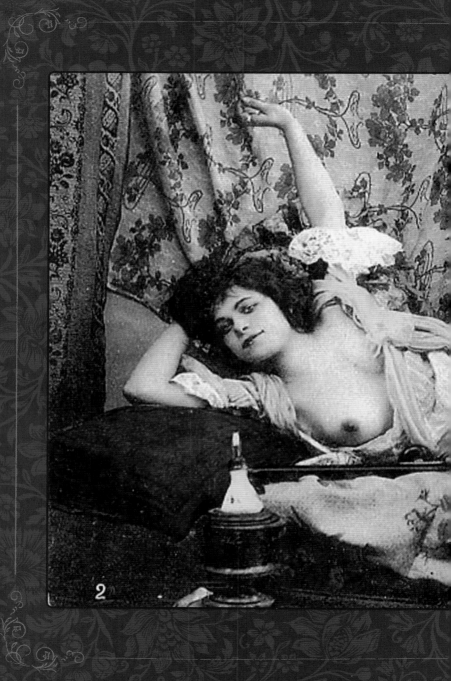

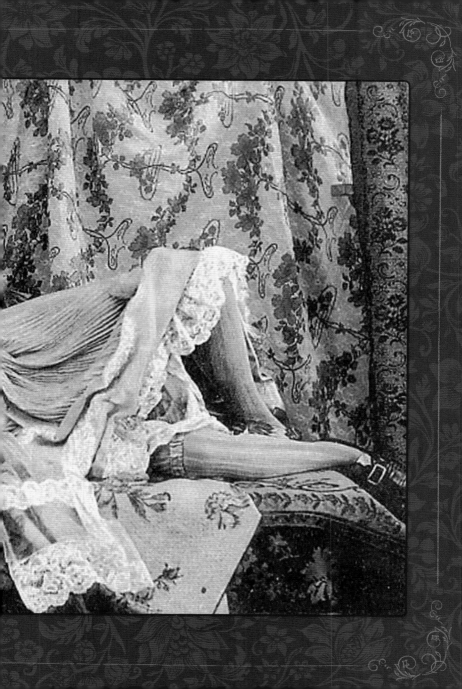

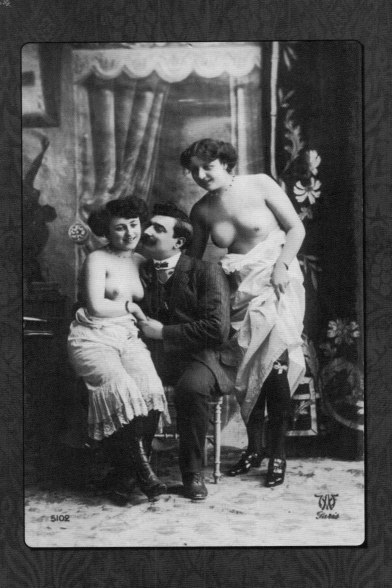

5102

Maison Clos

The bordello, or *maison clos*, was an institution of
the underground sexual life of urban Victorian
society. Behind its closed doors, men could let go
of their repressions. Hence these images
represented not just erotic pleasure, but a kind of
escape and freedom, too. They fueled fantasies of
Turkish harems, elegant courtesans, and lesbian
orgies. Showing a man in the picture, especially a
man made anonymous with his face concealed or
masked, made it easier for the viewer to
interpolate himself into the scene. For the first
time these decadent encounters were tangible,
interchangeable, collectible. Naughty country girls
newly arrived in the big city, exotic beauties from
afar, all manner of women offering all manners of
pleasure to any man—this was the promise of the
bordello, the illusion sold by the postcard.

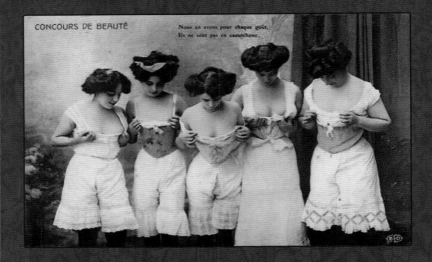

CONCOURS DE BEAUTÉ

Nous en avons pour chaque goût.
Ils ne sont pas en caoutchouc.

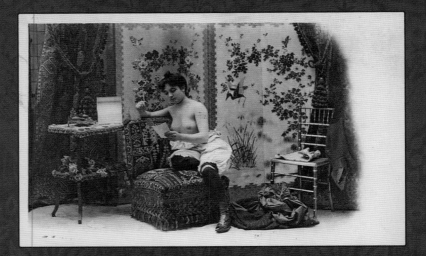

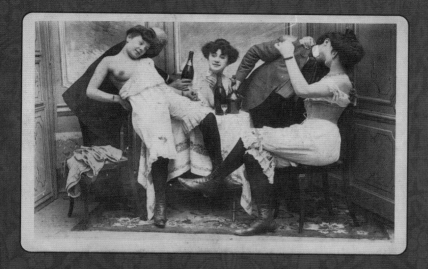

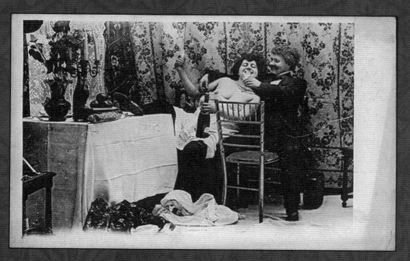

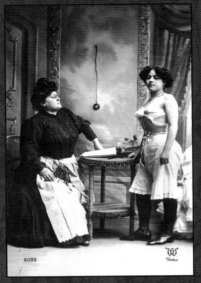

5093

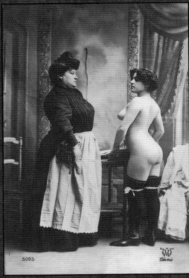

5093

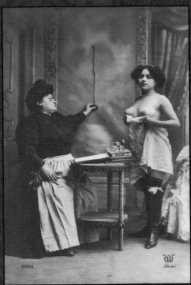

5093

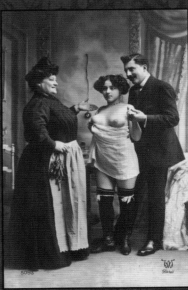

5093

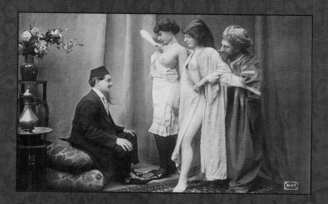

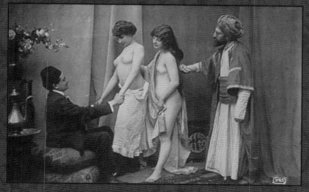

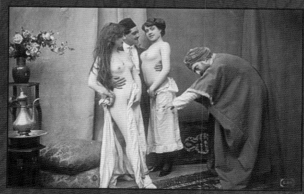

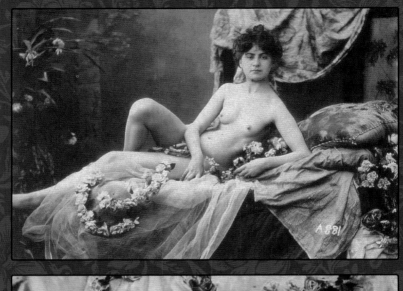

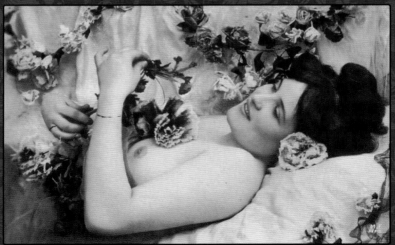

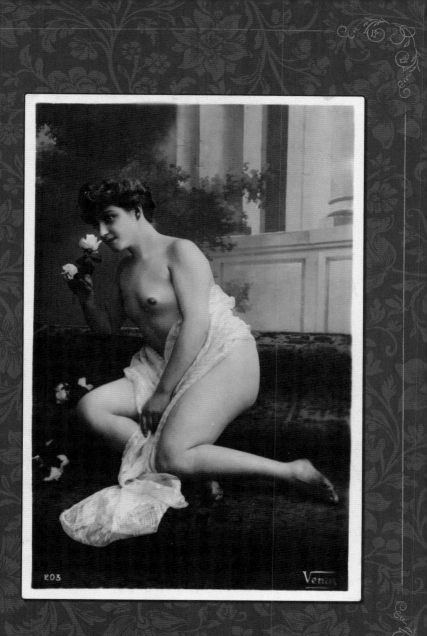

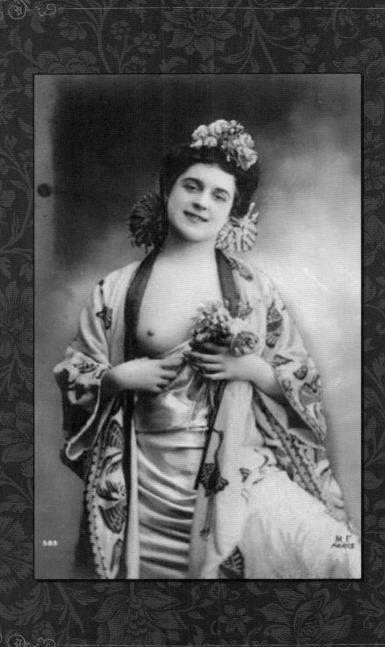

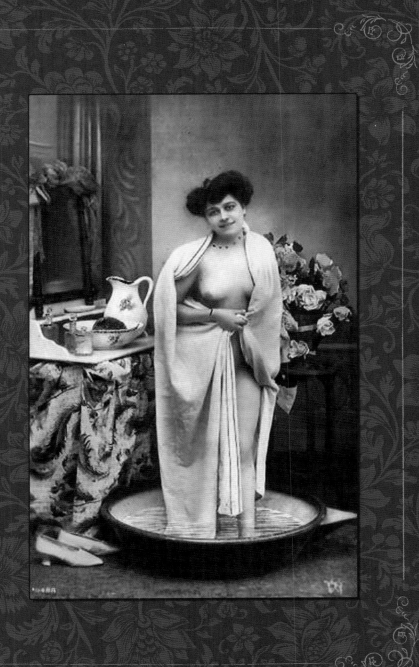

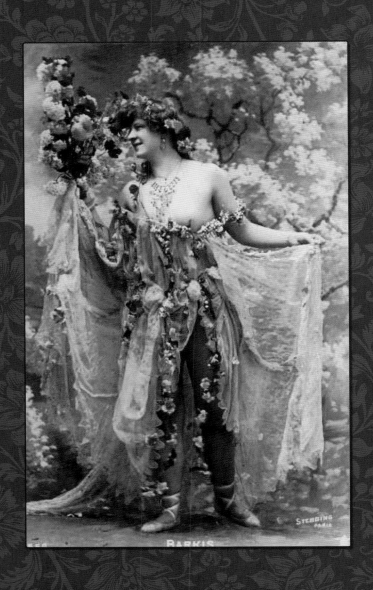

BARKIS

STEBBING
PARIS

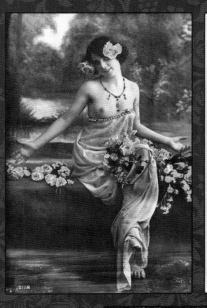

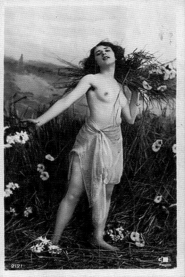

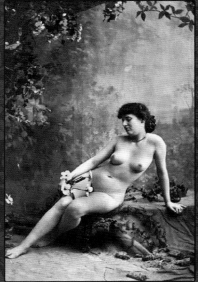

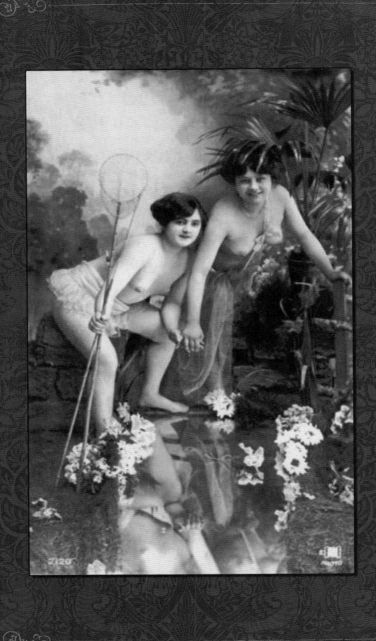

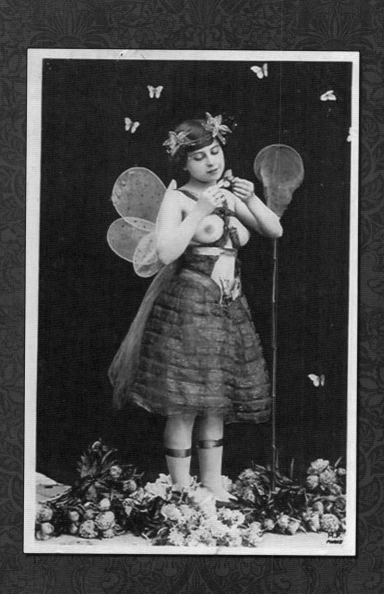

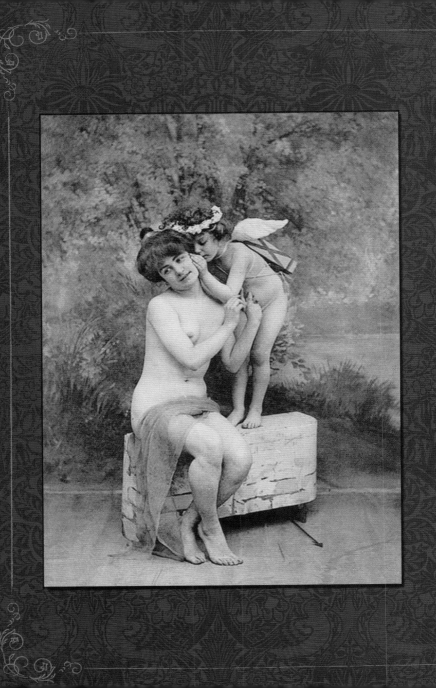

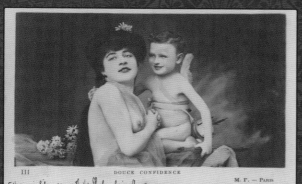

III DOUCE CONFIDENCE M. F. — Paris

5 h. je suis libre si non 3h 1/4 Ph bon baiser J.

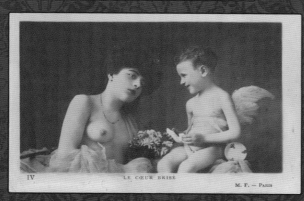

IV LE CŒUR BRISÉ M. F. — Paris

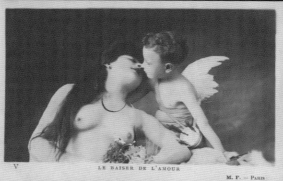

V LE BAISER DE L'AMOUR M. F. — Paris

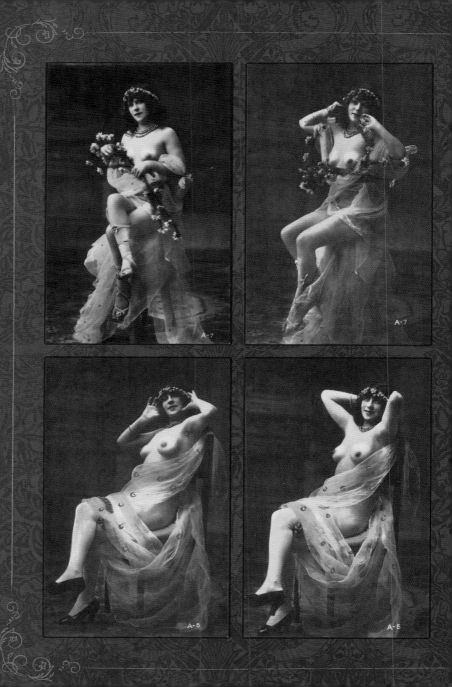

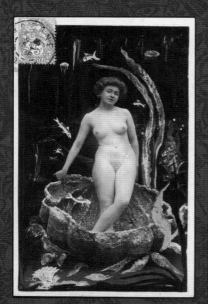
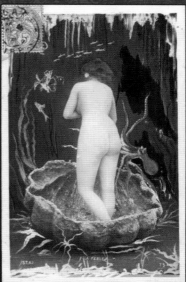
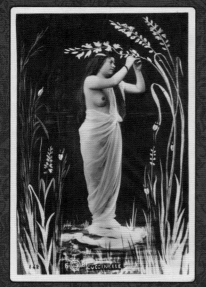
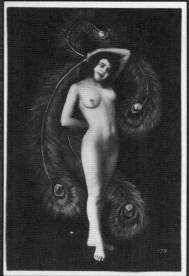

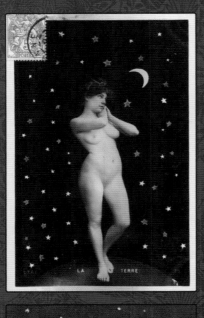

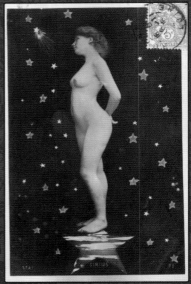

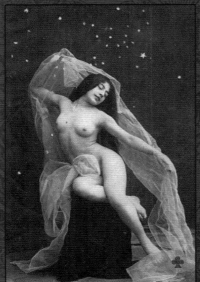

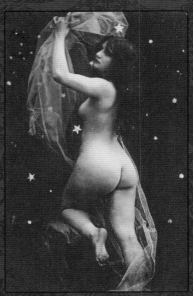

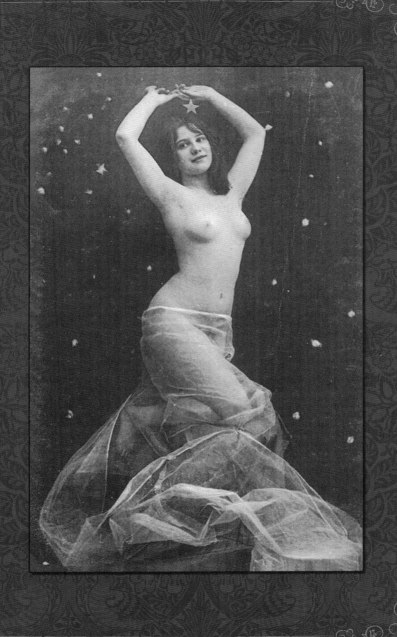

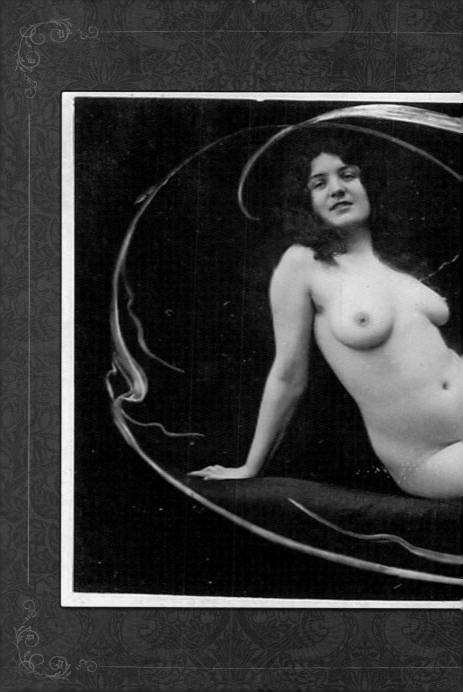

N° 116

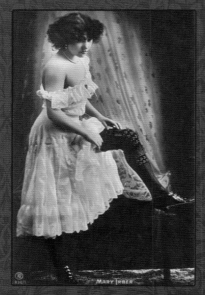

MARY IRBER

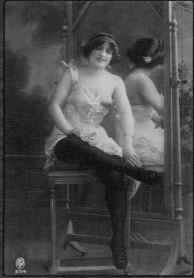

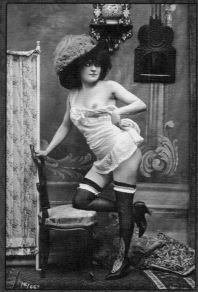

76/667

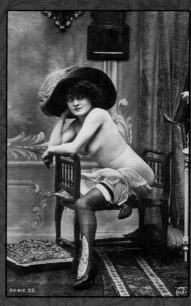

SÉRIE 32

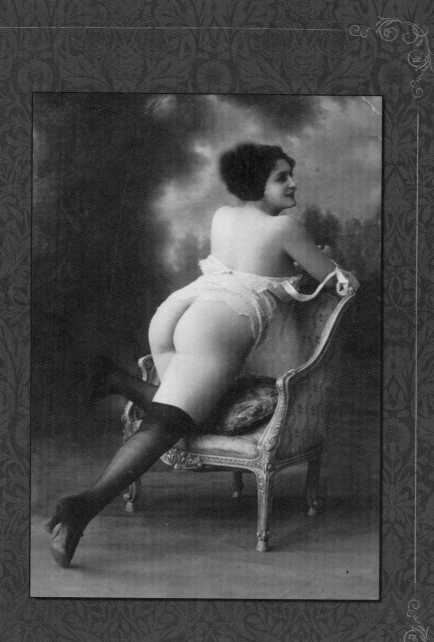

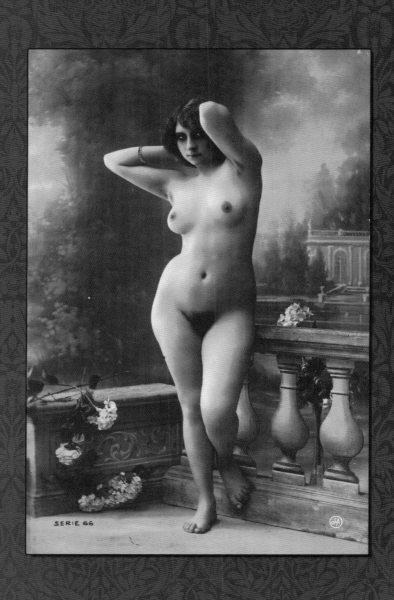

SERIE 66

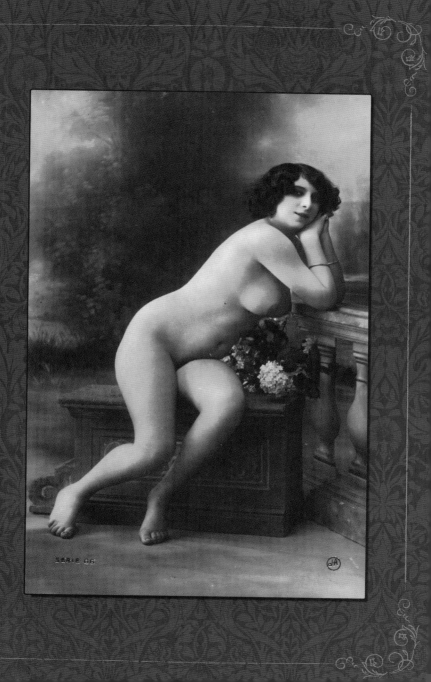

SERIE 86

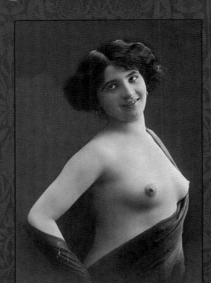

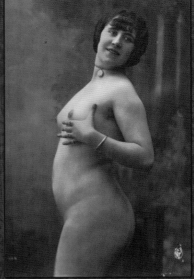

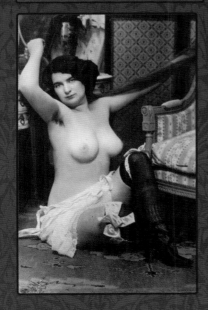

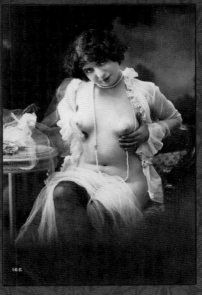

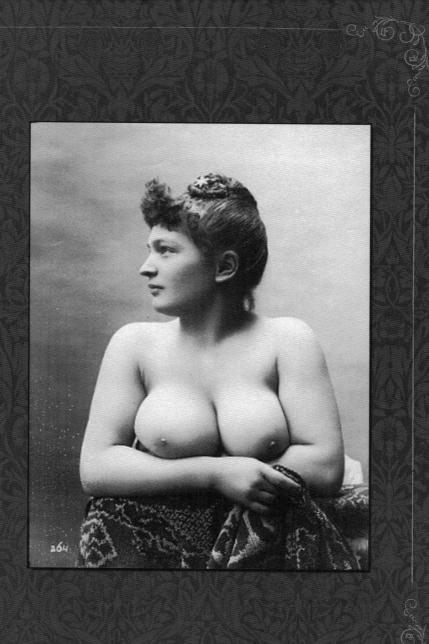

264

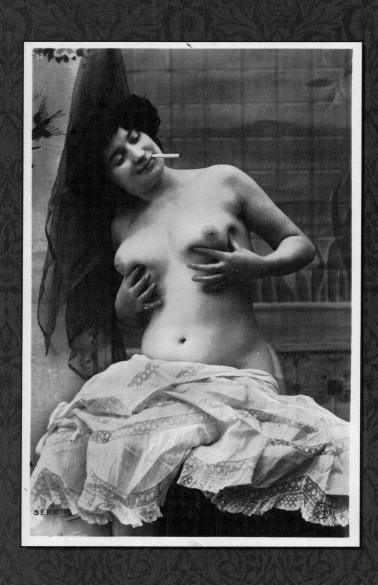

SERIE 1

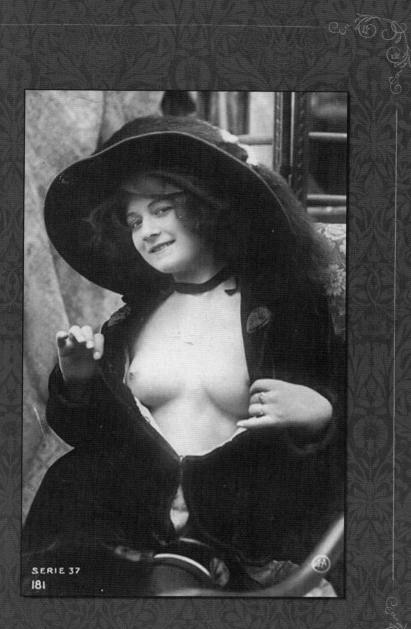

SERIE 37
181

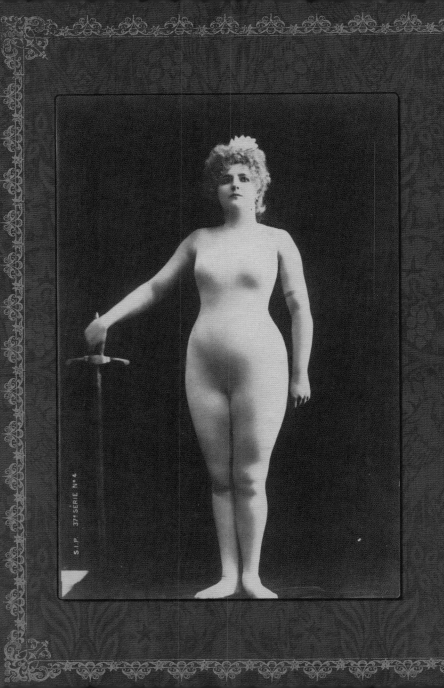

S.I.P. 37e SÉRIE N°4.

Nude but Not

Today these ladies in body stockings may seem
ridiculous, but in their time they were nothing
short of scandalous. Victorian and Edwardian
fashions for women were voluminous and
constrictive, comprising layer upon layer of
garments. This produced such an environment of
concealment that merely the sight of an exposed
wrist or ankle could set hearts racing. So to see
the outlines of the female figure, even when
completely sheathed, was a huge titillation. This
genre of the erotic postcard also allowed more
modest models to join in the fun. Here you will
find classical or amorous poses that seem to
belong more to the theater that to the brothel.
This connects to the fashion of the time for
famous actresses to have their portraits put on
postcards, which would them be traded and
cherished among fans and admirers.

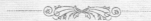

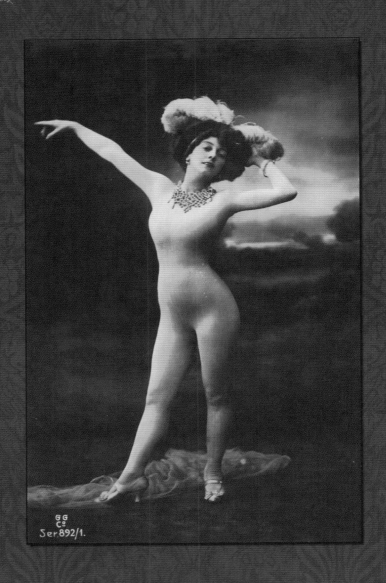

GG
Cº
Ser 892/1.

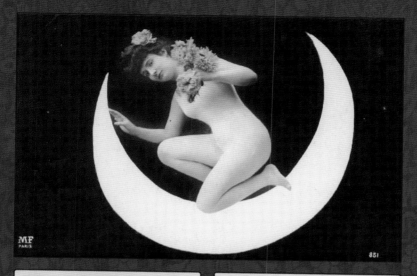

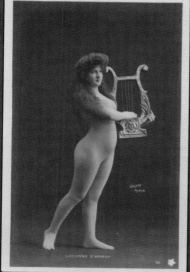

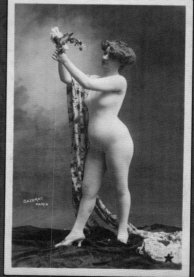

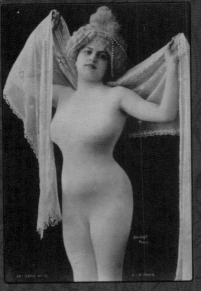

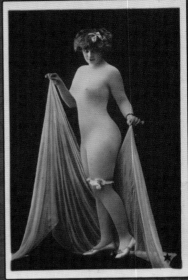

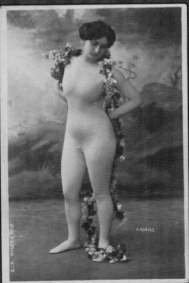

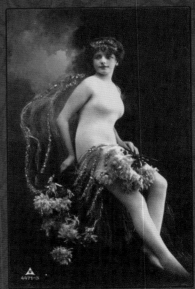

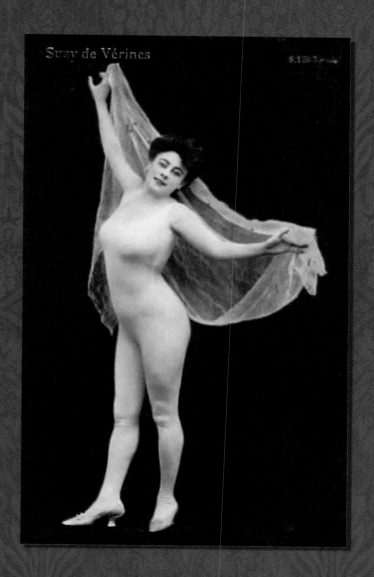

Suzy de Vérines

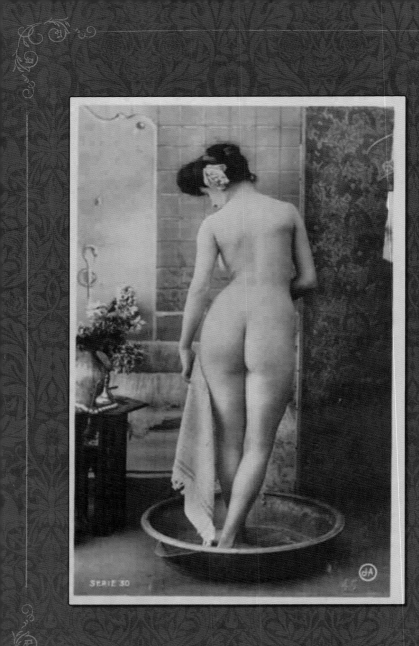

SERIE 30

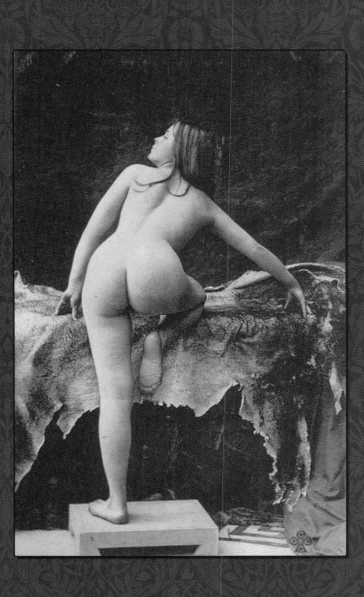

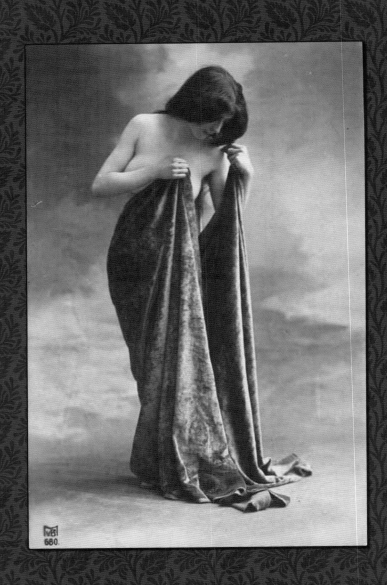

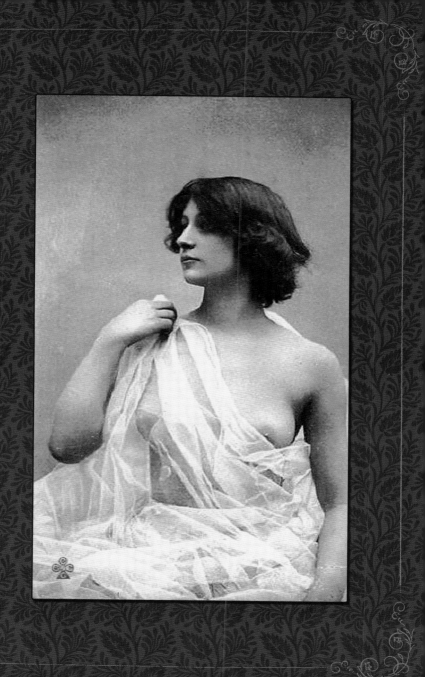

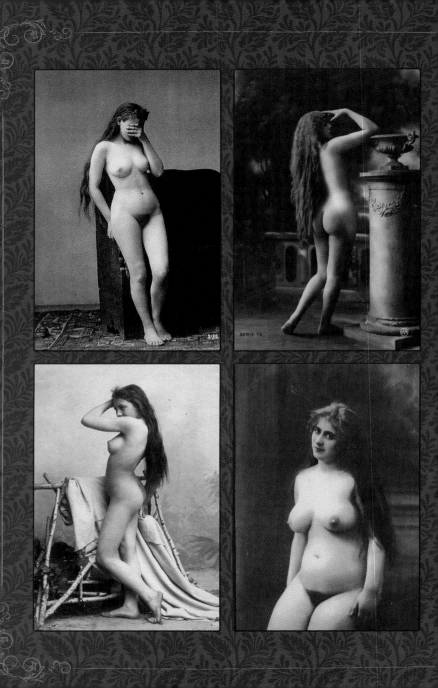

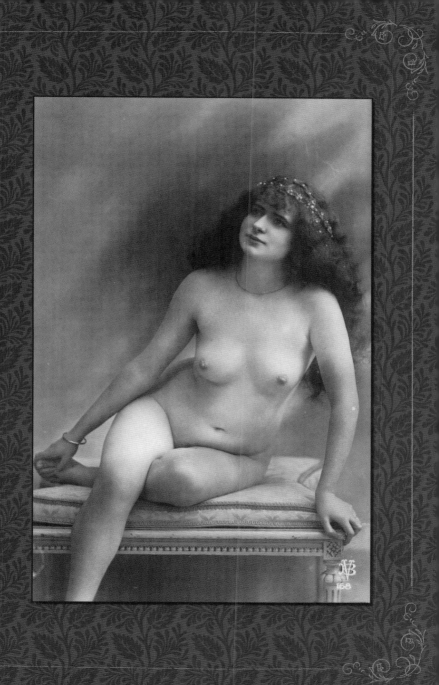

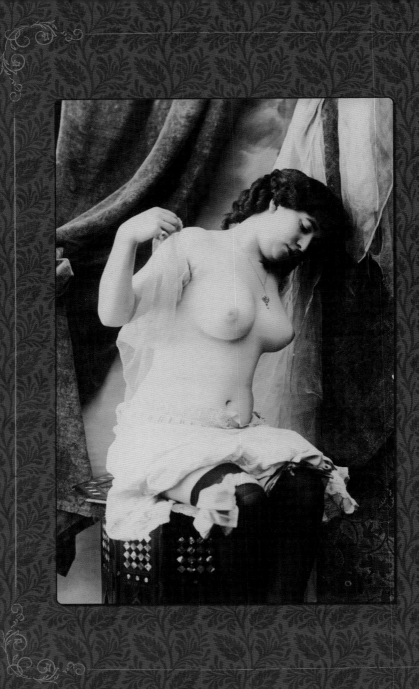

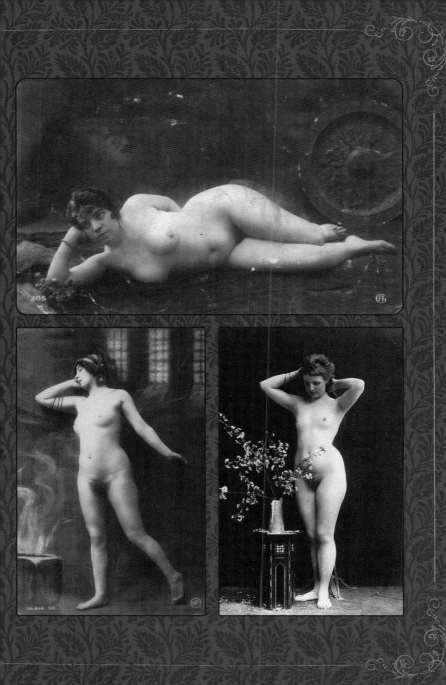

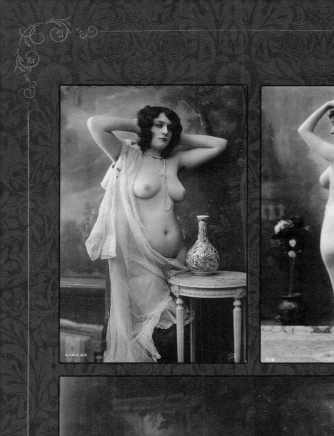
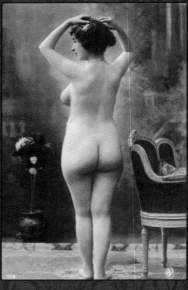
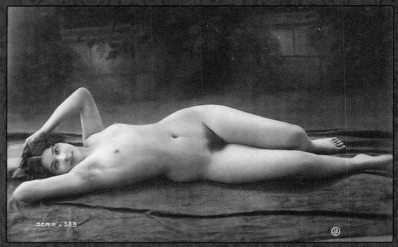

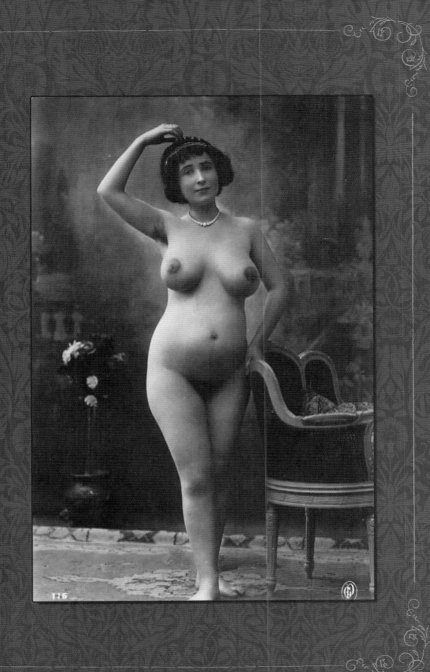

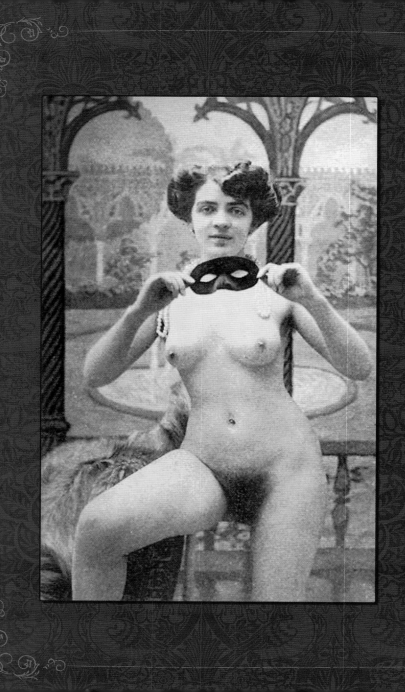

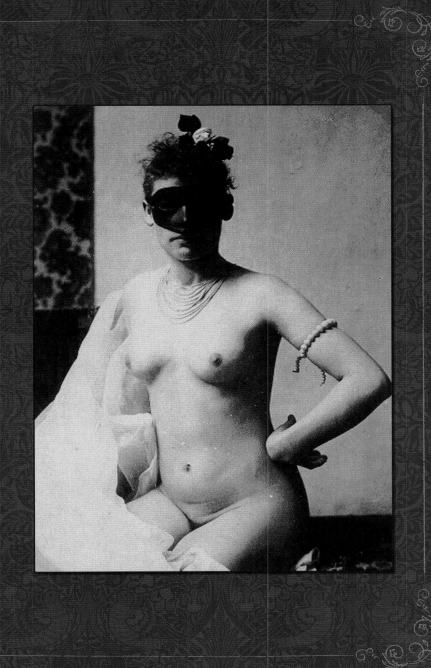

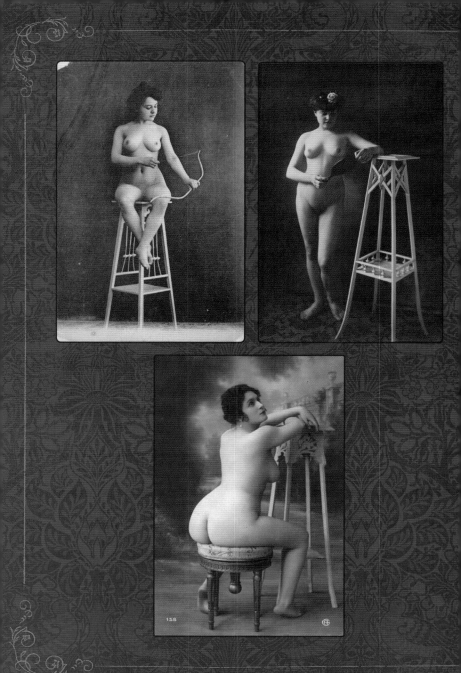

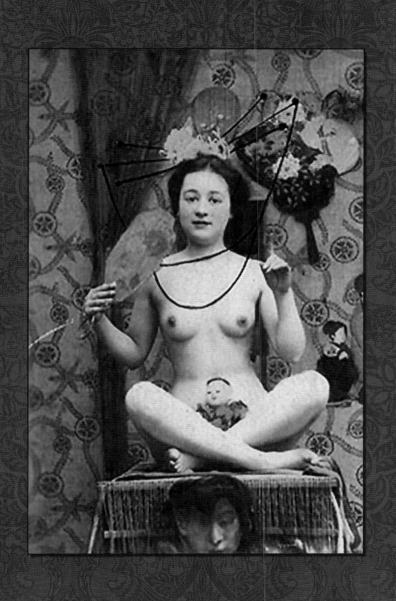

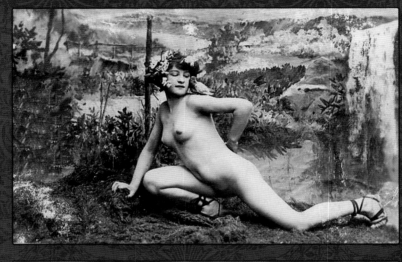

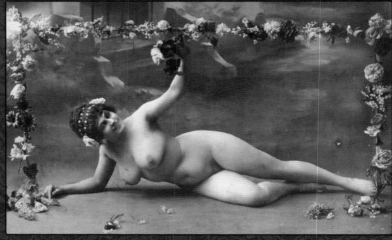

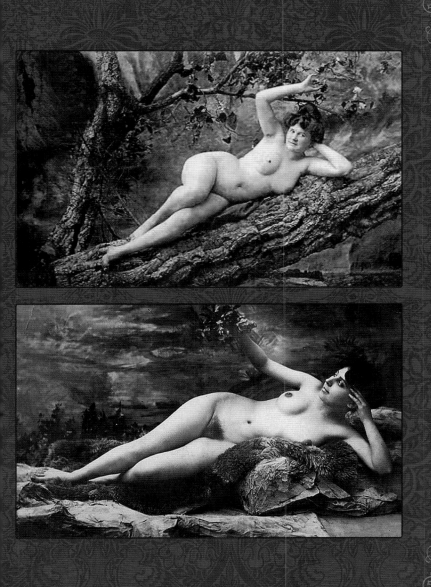

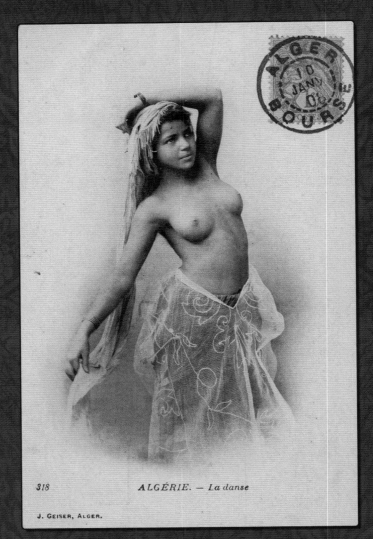

318 ALGÉRIE. — *La danse*

J. GEISER, ALGER.

The Lure of the Exotic

French colonies in Asia and Africa, especially
Algeria, had created a cultural craze for the
Orient near the end of the nineteenth century.
The lure of the exotic—for colors, textures,
and flavors new to European tastes—spread
through all the arts, including erotica.
Sir Richard Burton's 1883 and 1885
translations of *The Kama Sutra* and
The Arabian Nights did much to enflame the
fantasy of the Near East as a region of
tantalizing sensual delights. At the same time,
anthropologists launched ethnographic
campaigns and used photography to document
native societies in their colonies. These
naughty postcards developed as an offshoot
of this wave of cultural voyeurism.

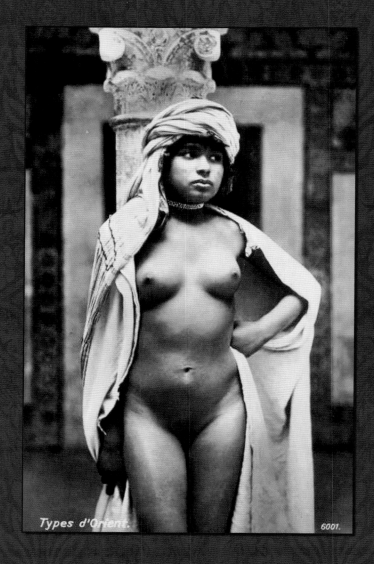

Types d'Orient.

6001.

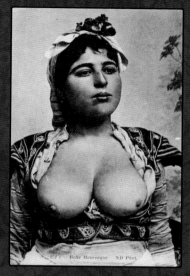

Belle Mauresque ND Phot

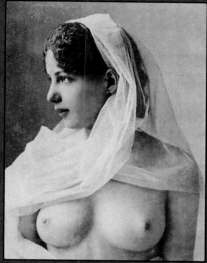

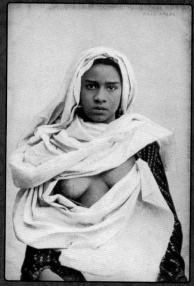

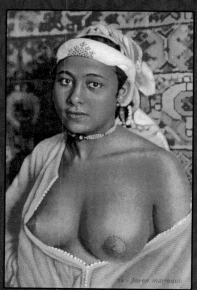

Joven marroqui.

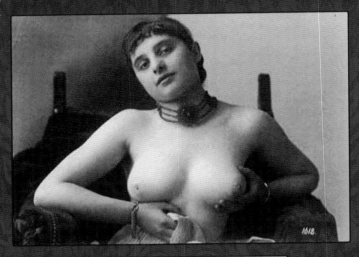

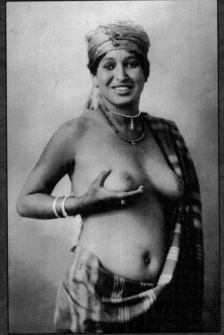

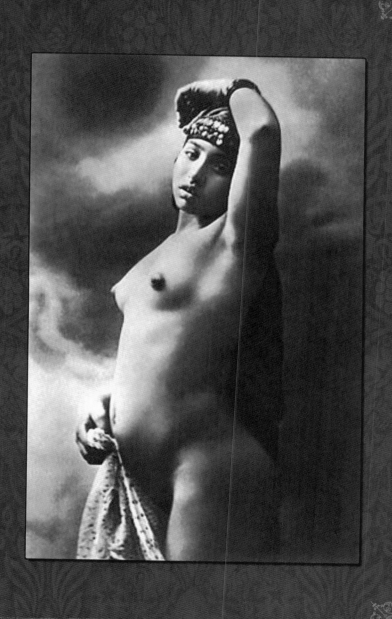

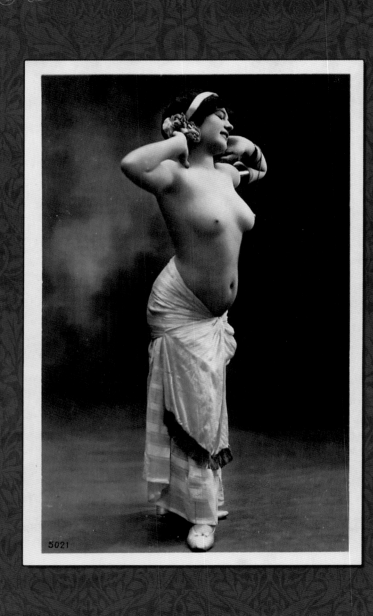

5021

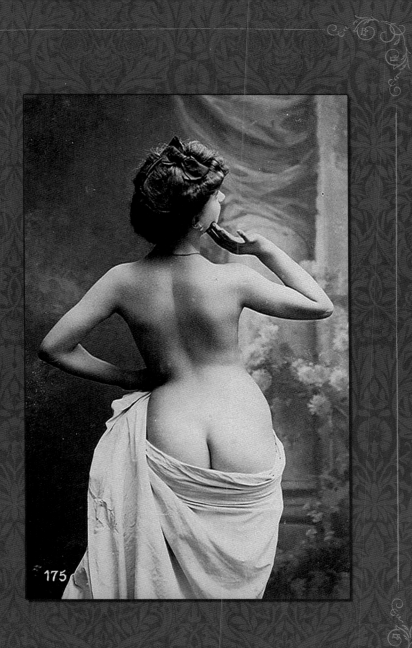

175

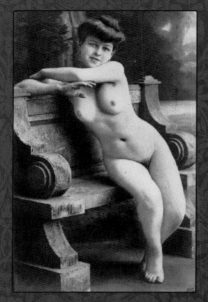
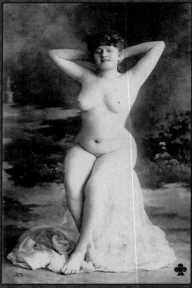
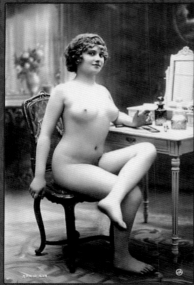
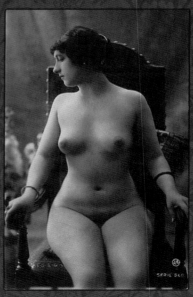

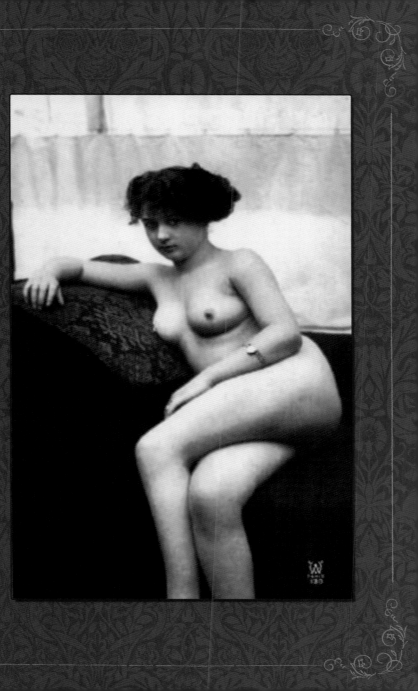

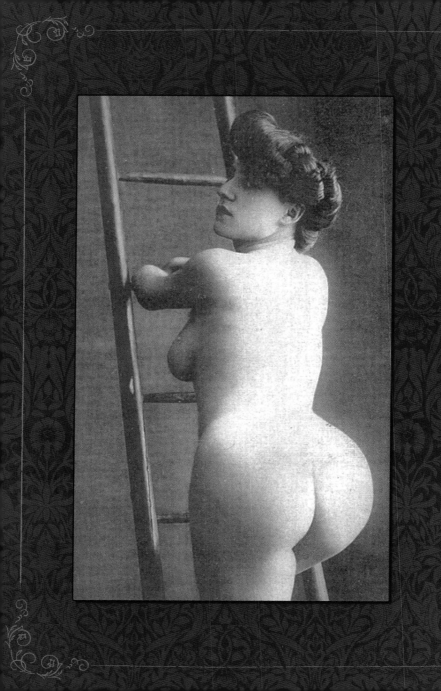

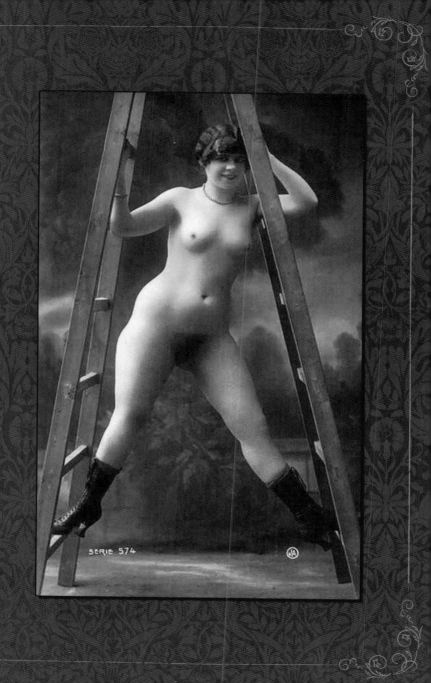

SERIE 574

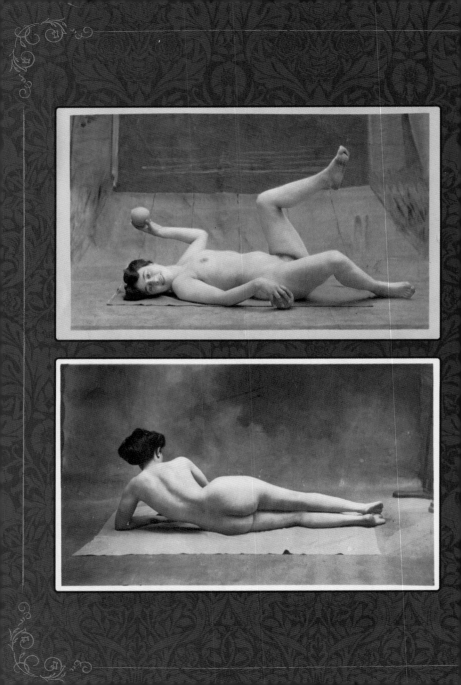

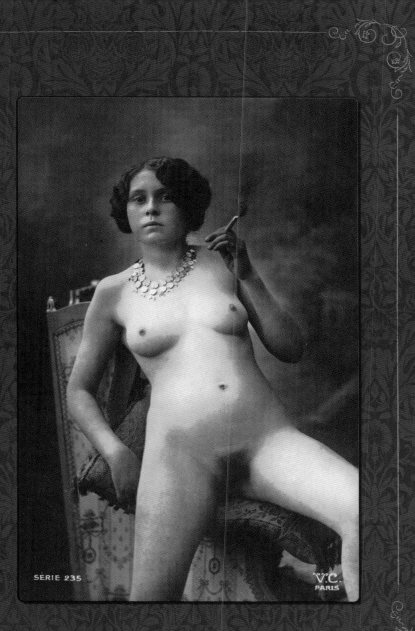

SÉRIE 235

V·C·
PARIS

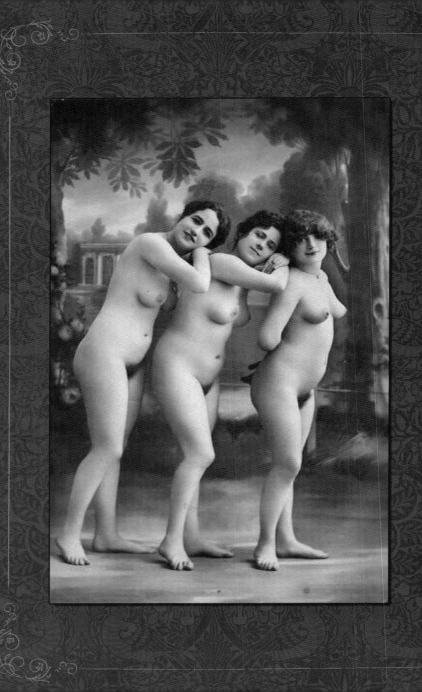

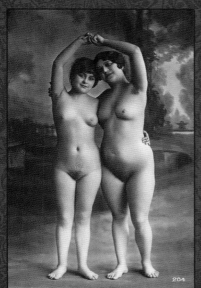

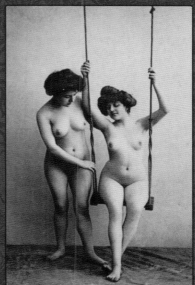

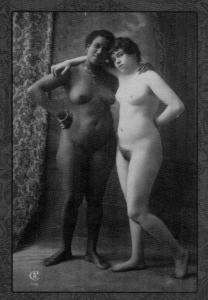

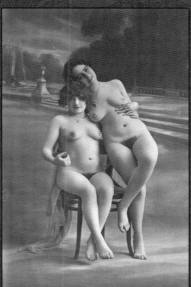

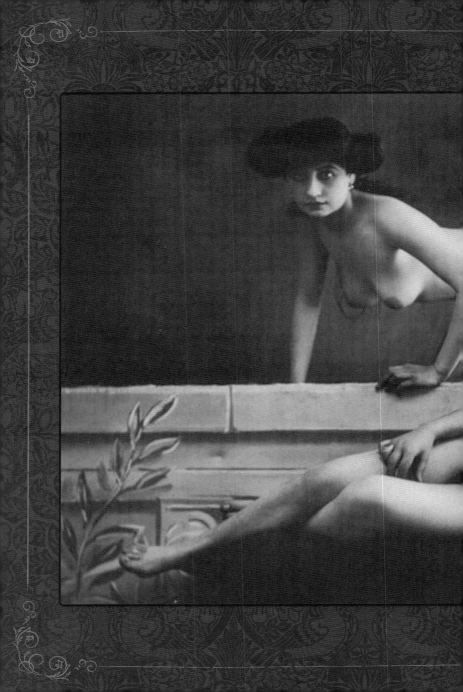

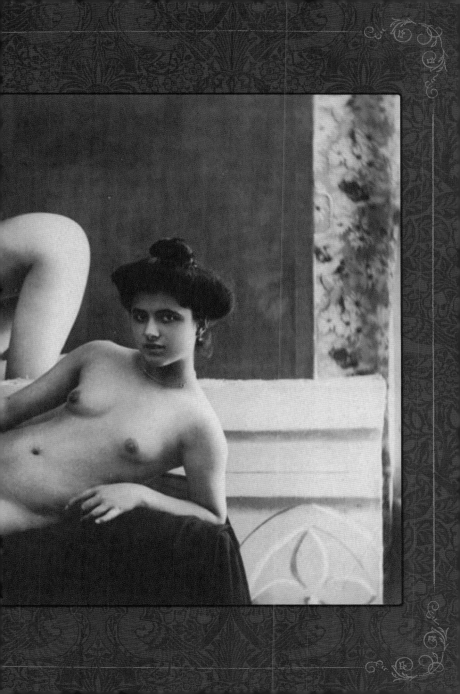

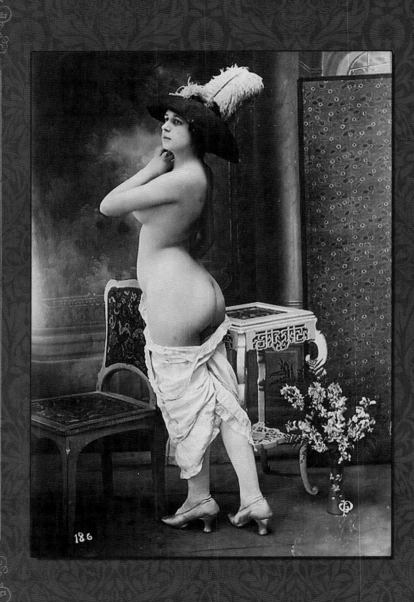

186

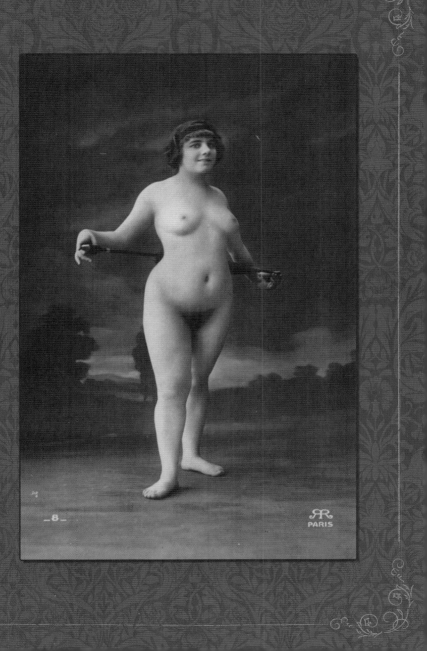

8

PARIS

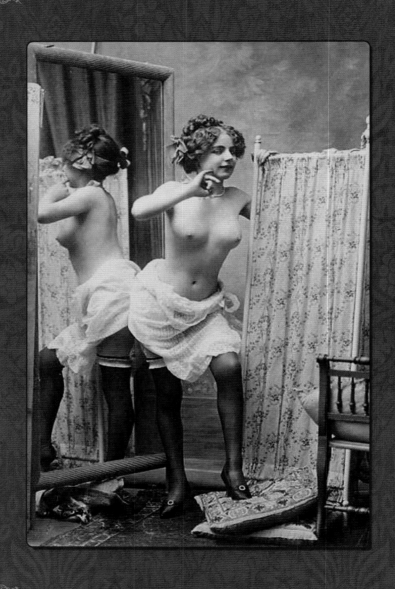

Miss Fernande

This playful, voluptuous darling was the muse and
favorite model of photographer Jean Angelou.
She has emerged from the thousands of nameless
beauties as one of the very earliest erotic
celebrities. Like many of the women who posed for
these cards, it is likely she came from the milieu of
maids, shop clerks, and prostitutes, seeking
economic opportunity outside of their domain.
"Miss Fernande," as she is known, seems to have
been an entrepreneur. Her Paris address was
stamped on the backs of some of her images.
These were business cards, of a sort. Perhaps the
very first sex symbol, she embodied turn-of-the-
century ideals of feminine beauty: petite but busty,
with a bountiful head of rich curls, and an evident
wit. As she grew older (and heavier), Miss
Fernande continued to pose for pictures, leaving us
some history of the hard-working life she led.

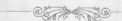

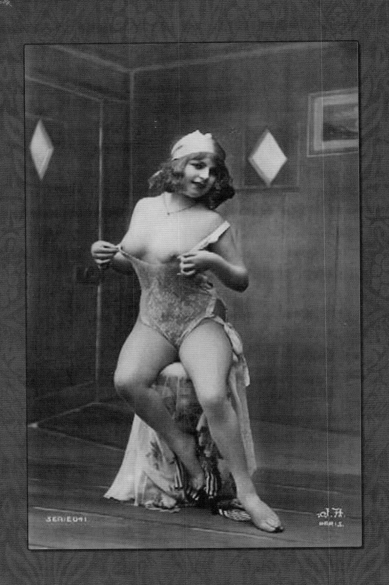

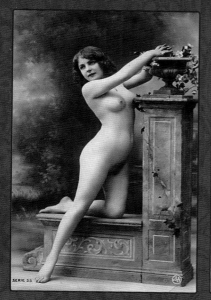

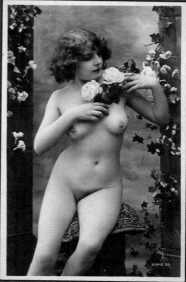

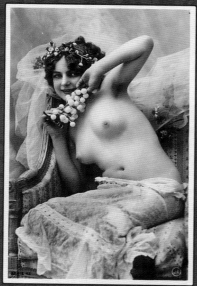

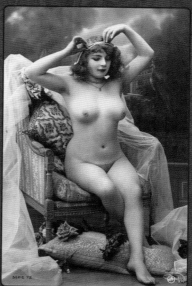

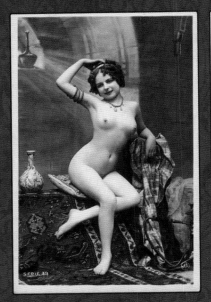

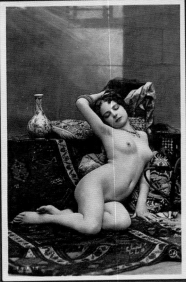

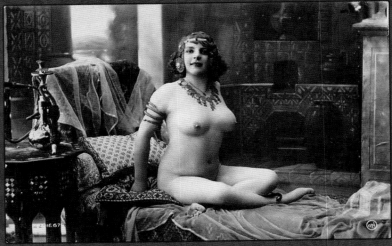

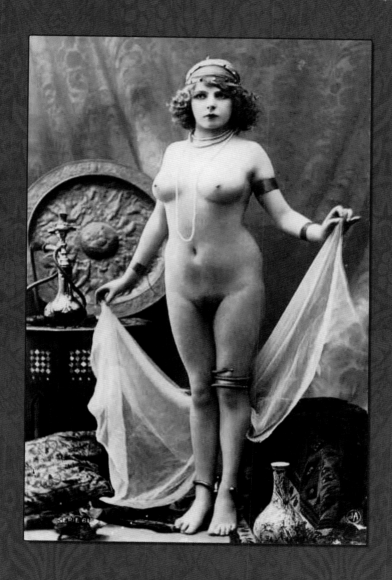

SÉRIE 61

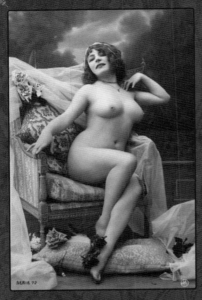

SERIE 72

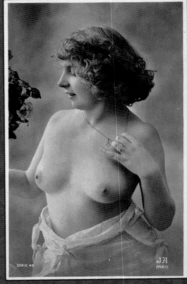

SERIE 45

JA
PARIS

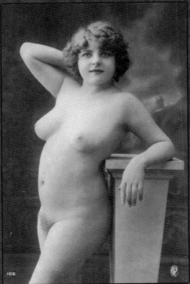

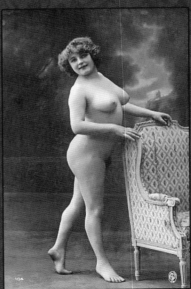

104

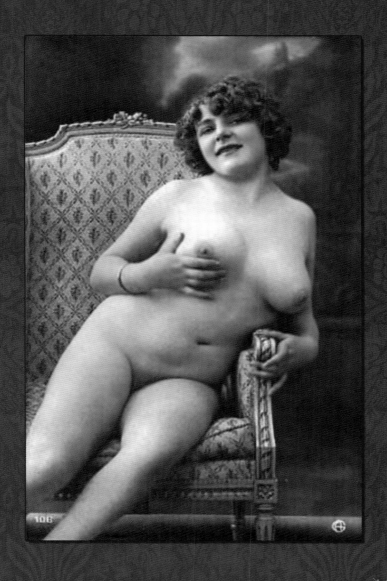

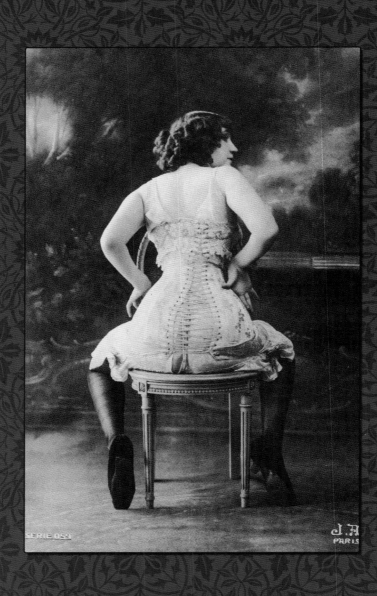

SERIE 059

J.A
PARIS

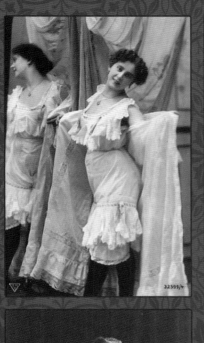

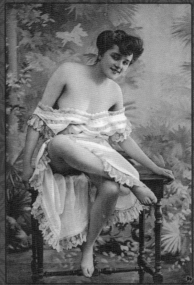

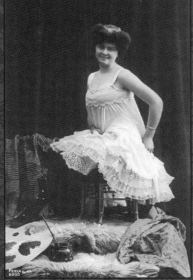

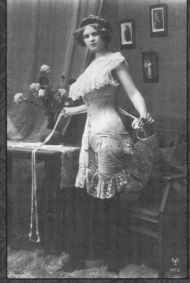

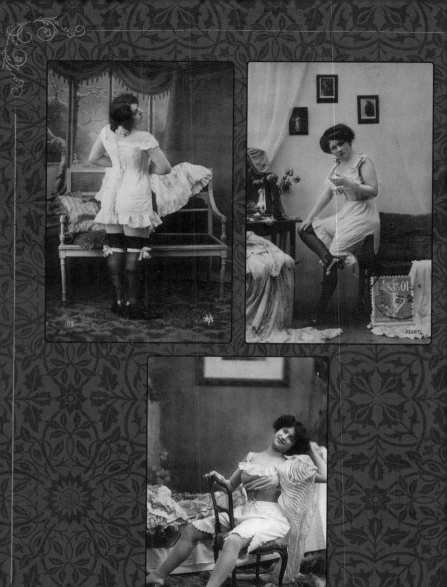

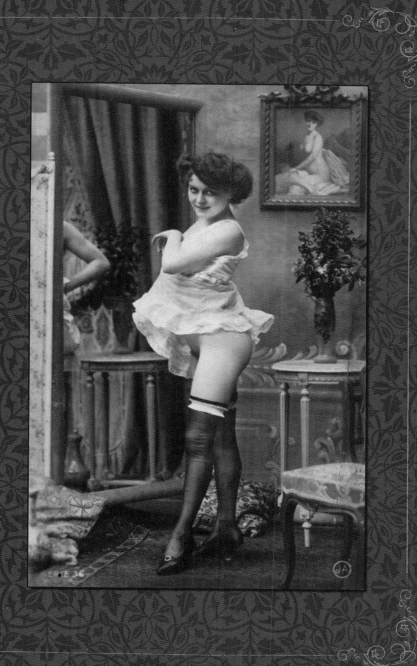

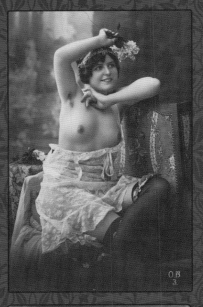

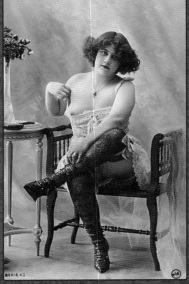

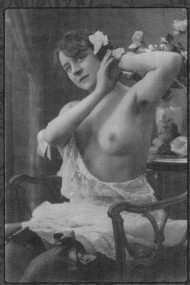

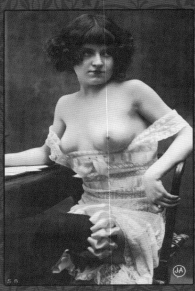

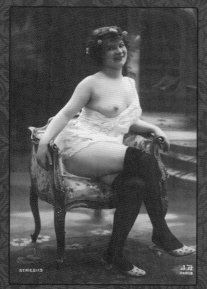

SERIES 113
J.A
PARIS

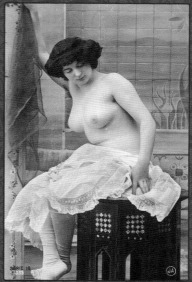

SÉRIE 18
J.A

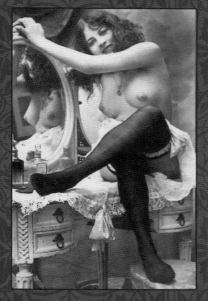

SÉRIE

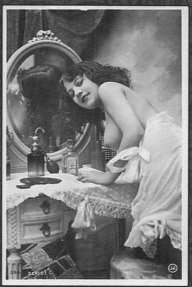

SÉRIE
J.A

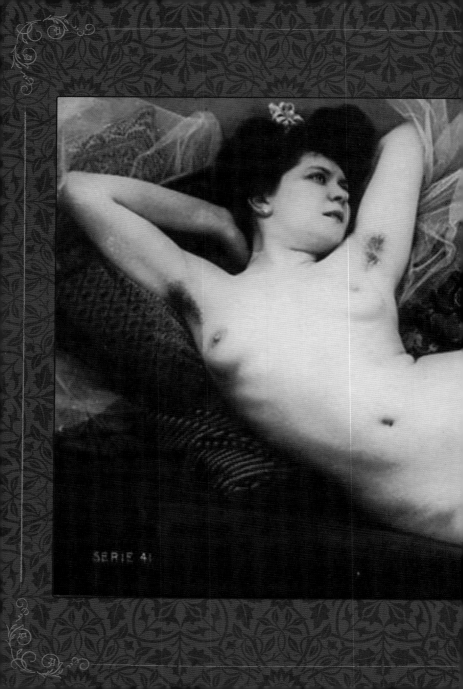

SERIE 41

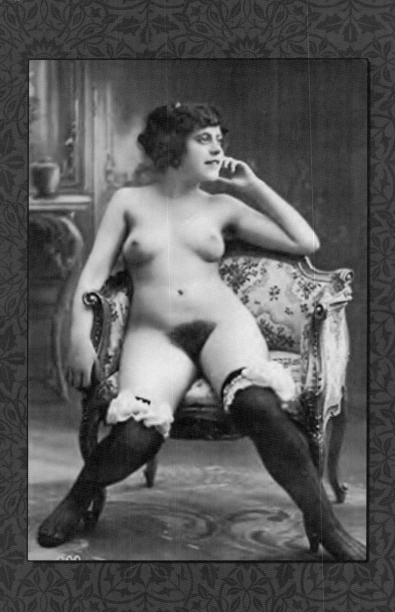

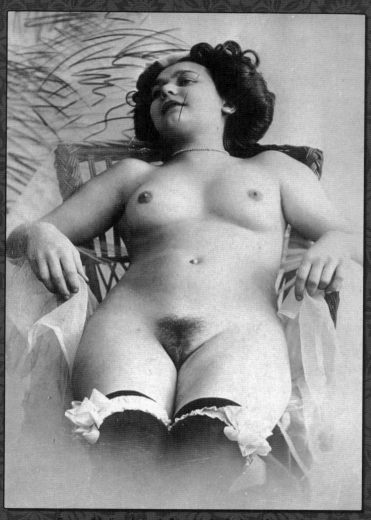

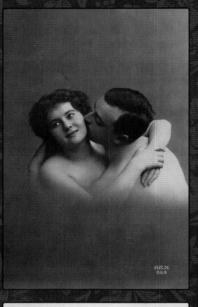

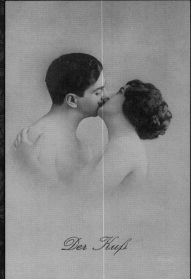

Der Kuß

Der Kuss

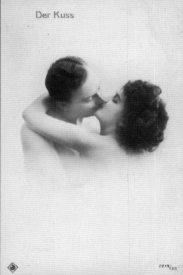

Der Kuss

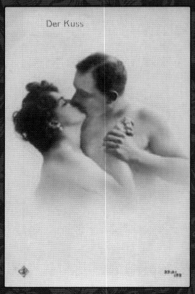